After

Institutions

Karen

Archey

After Institutions is the third installment of the Critic's Essay Series published by Floating Opera Press. Comprising long-form essays, the series gives voice to critics who offer thought-provoking ways in which to subvert or replace normative modes of discussing culture and the world beyond.

Other essays in the series:
Queer Formalism: The Return, by William J. Simmons
Remember the Details, by Skye Arundhati Thomas

To Inda Helene, so that institutions
may always serve you;

and to Janto,
for letting me close the door.

Contents

Introduction

It's an ordinary Monday morning in late 2020: rummaging through the garden shed, I find a maquette of the east wing of the Stedelijk's first floor, covered with miniatures of Institutional Critique artworks and sprinkled with bird food and mouse defecation; Hans Haacke's *Condensation Cube* is an empty fish tank fashioned out of jagged foam core and copy machine prints cut out by interns. Tiny photographs of ears fall off the model walls and scatter across the clip-art parquet floor. Back inside my living room, tote bags from travels past become receptacles for research books no longer needed—it's been enough time, the library wants them back. My partner shoves me with the books and maquette into an Uber XL headed to Museumplein, where security guards donning face masks help me fumble into the Stedelijk. I exchange the shat-on maquette and library books with folders containing my project documents for my own archive—who knows, maybe this isn't all for naught.

I walk out of the museum to find a lone hot dog seller and a gigantic KAWS fountain the size of a small building. A pink tram advertising the private Moco Museum next door—"Basquiat, Haring, Hirst, Koons, Kusama, Warhol & more!"—rolls up to Museumplein. I step in.

Working as a collection and exhibition curator for a large museum, I have had the opportunity to witness how such institutions absorb and relate to social movements— whether by exhibiting the work of politically active artists, releasing press statements, hosting educational events and programs, or launching internal initiatives. Over the past five years of my tenure at the Stedelijk Museum Amsterdam, this has often overlapped with my research on expressions of care in artistic practice, which itself was informed by a string of health limitations I my-self have encountered since my teenage years. Care, as experienced amid my upbringing and early adulthood in the United States, was so often a product of circum-stances, of being insured or uninsured—access to phys-ical and mental healthcare and other support systems, and finding time for recovery and stress reduction, was a privilege rather than a right. Since moving to Europe in 2016 and enduring a battery of new medical issues as a fully insured European resident, my understanding of care has become more collective: workable alternatives to casting care as a privilege to the few are possible and

require a reconsideration of what we consider human rights. "Care" is admittedly a nebulous word—its meanings can spill over into a litany of definitions. In this text, I refer to "care" as the constellation of systems and relations that enable an individual to lead a mentally and physically healthy and fulfilling life.

Many artists I have worked with on the topic of care—such as Luke Willis Thompson, Park McArthur, Carolyn Lazard, and Joseph Grigely—look toward the canon of Institutional Critique as inspiration for their own work. In my research, care institutions come logically into close proximity with art institutions—both are in crisis, and artists are wholly dependent on both of them. At this juncture, in June 2018 I organized "Practicing Care," a day of lectures with Thompson, Lazard, and Grigely, as well as artist Jesse Darling and writer Mirthe Berentsen, for Studium Generale, a transdisciplinary theory pro gram at Gerrit Rietveld Academie in Amsterdam. Following conversations with these artists and in light of the urgency of the degradation of institutions during the height of Donald Trump's presidency, I began researching for an exhibition that reinvigorated Institutional Critique as a praxis of care: *After Institutions*.

As an exhibition, *After Institutions* is something of a self-fulfilling prophecy: a show about the failure of institutions that was itself canceled. Oddly, it fits into a long genealogy of exhibitions of Institutional Critique

that have been called off or otherwise had trouble coming to fruition. Hans Haacke's 1971 Guggenheim exhibition, famously canceled before it opened, is the most notorious instance of this. Daniel Buren's participation at the Guggenheim International was also canceled in the same year, his work being removed after protests by artists such as Dan Flavin.[1] Further Institutional Critique exhibitions with fated launches include Valerie Smith's rained-on and critically underappreciated Sonsbeek '93, featuring artists such as Mark Dion and Tom Burr. Also noteworthy is that James Meyer's exhibition *What Happened to the Institutional Critique?* (1993), which is canonical to any reading of Institutional Critique, took place in a commercial gallery (American Fine Arts, Co. in New York) rather than a museum or other nonprofit space. More recently, *The Art of Critique* (2019–22), a project consisting of an exhibition series, publication, and symposium developed by curator Melanie Bühler for the Frans Hals Museum in Haarlem, the Netherlands, was also partially canceled amid the pandemic, yet lives on in book form.[2]

Similarly, *After Institutions* is an exhibition that almost was, but never came to be.[3] But it is also an essay that was originally commissioned as a lecture about the exhibition, which I'd been preparing over the course of 2019 and 2020. The lecture was to be given at the conference "Curating the Contemporary in the Art Museum"

at the University of Copenhagen in March 2020, about six months before the exhibition's slated opening date of October 2020. On March 12, as I was about to head to Schiphol Airport to fly to Copenhagen, the first series of lockdowns were announced throughout Europe. And so, the first year of the COVID-19 pandemic began: with a whiplash into nothingness, followed by an enduring vacuum that has slowly consumed jobs and lives, as well as exhibitions, performances, and any semblance of "normal" life. In the time since, I have both published parts of my research for *After Institutions* and delivered it as an online lecture. A true pandemic project, this book represents the definitive, expanded version of my research, in which I posit a new framework for Institutional Critique, giving it increased meaning against the backdrop of the groundbreaking social changes occurring today.

In the first section, I outline the research that formed *After Institutions*, beginning with a description of the paradoxical state in which art institutions find themselves today, with all the attendant issues and problems that the COVID-19 pandemic has brought into stark relief. Institutions are both economically and politically threatened to the point of dysfunction or even closure, while simultaneously finding themselves confronted with their own unjust, problematic histories. The first section also lays out how biography might motivate or inform an artist's critique of institutions of care, including museums.

In the second section, I sketch out the relevance of the canon of Institutional Critique—its artists, principles, and strategies—to delineate a working definition of its three waves, arguing for a reinvigoration of this canon. How Institutional Critique, with its increasing use of extra-aesthetic and nonvisual information, can be effectively displayed within public institutions with such a wide array of assumed knowledge bases, is a question that influenced my methodology in assembling *After Institutions*. One of the goals of the exhibition was to expand the understanding of what Institutional Critique could consist of, departing from its tether to Conceptual Art, and to challenge what we expect the critique of institutions to look like. To free Institutional Critique from Conceptual Art is also to challenge the whiteness and Eurocentrism of these canons and to gain the opportunity to use other forms of address and communication, thereby tapping knowledge bases currently underrepresented in the field.

To this end, the exhibition sought to reintroduce works that were *feeling* rather than *thinking* in nature— works that are expressive and metaphorical, that once seemed to be categorically opposed to the works associated with canonical definitions of Institutional Critique, which are outlined throughout this book. Thinking about Institutional Critique along broader, more inclusive lines allows us to position the work of some artists

14

as extending but also updating the idea of what it means to use critique as artistic practice. Some of the artists I discuss, like Zoe Leonard, come from earlier in the art-historical timeline, while others, such as Cameron Rowland, began working more recently. However, they both expand what it means to critique our institutions, thus permitting a more charitable and deeper understanding of the role biographical and cultural context plays in an artist's work. Finally, in the brief conclusion, I offer some remarks on where expanded definitions of Institutional Critique might lead.

1 Alexander Alberro, "The Turn of the Screw: Daniel Buren, Dan Flavin, and the Sixth Guggenheim International Exhibition," *October* 80 (Spring 1997).
2 Melanie Bühler, ed., *The Art of Critique* (Haarlem and Milan: Frans Hals Museum and Lenz Press, 2022).
3 After nearly a year of postponements, *After Institutions* was canceled due to a variety of factors, some of which are named in this essay. It is my personal opinion that discursive group exhibitions are seen as "difficult" within many larger-scale museums such as the Stedelijk. Group exhibitions are seen as less marketable than solo exhibitions and also more complicated due to the large number of loaned works that must be arranged with many different lenders. In the end, *After Institutions* was not given priority to move forward by the museum's stakeholders.

I
The State of Institutions

Economic Precarity and the Institution

Due to a number of economic and political conditions, institutions throughout Western Europe and the United States are operating under conditions of financial precarity. Thanks to the reversal of pre- and postwar advances in economic and social equality, and the acceleration of nearly forty years of neoliberal policymaking—including tax breaks for corporations and the wealthy—tax revenue has dropped, and the welfare state has waned.[1] Local and national governments subsequently lack a willingness to spend domestically, cutting essential programs such as nutrition assistance. Within the arts, states are increasingly unwilling to fund cultural institutions as was once

the norm, at least in Europe. We've seen a march toward privatization among once-public institutions, and, within the field of art more specifically, we've watched museums being forced to become financially "independent" entities that no longer depend on income from the state, or hybrid versions that relieve some funding pressure from governments. This has been the case in the US for some time, but now it is occurring in countries such as the Netherlands. The Stedelijk Museum Amsterdam, where I work as Curator of Contemporary Art, was made a half-independent nonprofit organization in 2005.

As the largest museum for contemporary art and design in the Netherlands, and specifically the municipal art museum of Amsterdam, the Stedelijk cares for the city's art and design collections. Its building is owned by the city of Amsterdam, and its staff's salaries are subsidized by the city as well. Anything beyond the bare minimum, including all exhibition programming, must be either fundraised or earned via ticket revenue, which incentivizes the Stedelijk specifically, and museums generally, to pull in visitors by programming highly marketable exhibitions. While this may not be inherently problematic, museums also have an obligation to their professional field (e.g., to exhibit artists not yet widely known), and those obligations may not always dovetail with the public's attention and interest, or budget bottom lines. In other countries, such as the United States,

the majority of museum funding comes from foundations, private individuals, and corporations, which can result in strange, ethically dubious effects, such as the naming of minor spaces after patrons or the showcasing of board members' collections through exhibitions. On top of that, these institutions sometimes solicit donations from individuals who made their money unethically. The phenomenon of institutions accepting funding from these individuals and the subsequent reputation gain they are afforded has become so commonplace that it has earned a neologism: *artwashing*. Recent artwashing scandals include the 2021 resignation of MoMA board chairman, the investor Leon Black, due to his ties to sex trafficker Jeffrey Epstein.[2] Similarly, arms manufacturer Warren Kanders had served on the board of the Whitney Museum of American Art, and after eight artists withdrew their participation in the 2019 Whitney Biennial in protest, Kanders quit the Whitney's board. Artists Hito Steyerl, Nan Goldin, and the latter's activist organization P.A.I.N., are just a few of those who have protested the acceptance of funding from the Sackler family, the owners of Purdue Pharma largely seen as responsible for igniting the American opioid epidemic with their aggressive marketing of OxyContin. The artists' efforts have been largely successful, with Tate Modern in London, the Metropolitan Museum of Art in New York, and the Louvre in Paris all removing mentions of the Sackler name from their walls.[3]

Though most exhibition funding in American museums comes from private sources and thus reflects to some extent the interests of the private individuals and corporations that finance institutions, this by no means precludes the staging of, paradoxically, populist exhibitions. The blockbuster show—an exhibition meant to appeal to "all" audiences (or the spurious "new audiences")—while extraordinarily resource-demanding and not always financially beneficial,[4] is still pursued by virtually every museum on the planet. Recent art museum blockbusters include *KAWS: What Party* at the Brooklyn Museum (2021), the *Rain Room* by Random International at MoMA (2013), and Tim Burton and Björk's exhibitions at MoMA (2009 and 2015, respectively), which stretch the definition of art in order to make ends meet. The United States' first blockbuster, *Treasures of Tutankhamun* (1976–79), was seen by approximately eight million people over the span of three years in seven venues. Yet its organization bore such an astronomical budget that the exhibition prompted Congress to pass the Arts and Artifacts Indemnity Act in 1975, as individual venues could not bear the financial burden of insurance fees for assuring the sanctity of King Tut's treasures.[5]

If these economic pressures weren't enough, the COVID-19 pandemic has made them only more acute. Museums across the world have been forced to close for months on end. Naturally, these institutions have

experienced a direct loss of revenue from ticket sales, but they have also suffered a loss of funding from ancillary sources such as cafés and bookstores, as well as project-specific income like exhibition grant fundraising due to reduced exhibition turnover—the fewer exhibitions you do, the fewer grant opportunities you have. Given that museums were already operating under financial pressure, the larger-than-expected gaps in yearly budgets have led some institutions to a state of crisis. Deaccessioning, or the selling of works from a museum collection, long taboo in the museum world, has unfortunately come to the fore as a viable option for closing funding shortfalls, made more pressing during the pandemic.

A prime example of the trend toward deaccessioning can be found in an announcement from the Association of Art Museum Directors (AAMD), a watchdog organization representing 240 North American museums, on April 15, 2020. The AAMD announced a series of resolutions stipulating that, for two years, it would allow museums to deaccession works from their collection to cover operating costs,[6] suspending the normal battery of sanctions and other forms of censure ordinarily undertaken in such instances. In turn, several museums sold off objects in their care, including the Brooklyn Museum, which raised $31 million in October 2020 by selling works from their modern and Old Masters collections, including

works by Lucas Cranach the Elder and Gustave Courbet.[7] The Baltimore Museum of Art put up several works for auction, expecting to net $65 million at Christie's, only to withdraw them hours before the sale after fourteen current and former art museum directors sent an open letter to the chair of the museum, urging it to reconsider its planned sale of artworks.[8] Former museum board members also rescinded pledged gifts of a roughly equal amount, $50 million.[9] The controversial policy is unlikely to be extended by the AAMD, as an informal March 2021 poll of association members voted 91–88 against asking its trustees to even explore amending its deaccessioning guidelines.[10]

Deaccessioning is not just an American phenomenon: in Amsterdam in 2020 and 2021, two politicians from different political parties (Diederik Boomsma of the Christian Democratic Appeal and Wil van Soest of the Partij van de Ouderen) suggested that the municipality sell some of the "thousands of expensive works that are sitting around gathering dust in storage."[11] Boomsma suggested Roy Lichtenstein's *As I Opened Fire* (1964) as a good example of a work to sell from the Stedelijk Amsterdam's collection, despite it being a prominent work in the museum's permanent collection display and certainly not sitting in storage. Regardless, the politicians claim its sale could generate €50 million of revenue, enough to bail out the city's entire cultural sector.

While the ease of generating income through the sale of artworks may seem like a harmless solution to the temporary financial crisis brought on by the COVID-19 pandemic, the disadvantages to deaccessioning abound. Firstly, donors are clearly disincentivized to donate their work to museums if there's a threat it will be sold to keep the lights on a few years later. There's also an ethical quandary. These sales frame artworks as fungible assets within a museum's financial portfolio and forgo the implicit promise an institution makes to care for such work in perpetuity. What is deemed expendable one year may accrue more cultural importance a decade later. Moreover, if prices of art objects continue to break records and museums continue to experience the financial pressures mounting over the past few decades, they will never again have the financial capital to buy back such treasures. As museums play a crucial role in the creation of the art-historical timeline, these advances in privatization render it more difficult for museums both to represent past historical moments and to collect from the moment in which they are operating.

Political Pressure

The economic pressure on institutions is coupled with challenges from all sides of the political spectrum. Throughout Eastern Europe, far-right parties have taken

control of high-profile cultural institutions, replacing art organization directors with political appointees. In Poland in September 2019, for example, longtime director of the Ujazdowski Castle Centre for Contemporary in Warsaw, Małgorzata Ludwisiak, received notification that her contract, ending in December 2019, would not be renewed.[12] In Hungary, where the Right has a parliamentary majority, Prime Minister Viktor Orbán has altered the funding structures for live art in order to control and gain influence over the cultural landscape there.[13] And in Slovenia in December 2020, on behalf of the erstwhile newly formed right-wing government, the country's culture minister, Vasko Simoniti, fired Zdenka Badovinac, the curator of Ljubljana's Moderna galerija since 1993, a move that prompted concerned letters of protest from international organizations such as the International Committee for Museums and Collections of Modern Art (CIMAM).[14] In a similar trend, in the United States, Donald Trump attempted to defund and effectively shut down the National Endowment for the Arts (NEA) during every year of his presidency.

In general, the international rise of right-wing populism over the past half-decade dovetails with an ideological aversion to intellectual life, of which the fine arts are seen as the jet-set figurehead. As justification for their attacks on art institutions, populists pit contemporary art against "real life" and "real workers," as if the people who work in the art industry aren't real, don't matter, don't experience

economic stress, and aren't impacted by job loss. But according to Eurostat, the European Union's statistics bureau, in 2019 there were 7.4 million people employed in the culture industry across the European Union, which makes up 3.7% of the (erstwhile) twenty-seven-member state's workforce.[15] (This is of course a larger estimation than just the art industry.) The mining and quarrying sector in the EU, by comparison, employed 413,000 people in 2017.[16] Meanwhile, the cultural sector in the US makes up 4.5% of the country's gross domestic product.[17] Policy regarding the arts therefore impacts a considerable populace of workers—a museum employee laid off because of budget cuts may have a similar feeling of disenfranchisement and hopelessness for their industry as a coal miner would about theirs. Finding oneself unable to pay rent or a credit card bill creates the same pit in the stomach regardless of what industry one works in. And, further, the same social welfare safety nets are used by everyone; yet, those social welfare institutions, in tandem with the mounting troubles facing art museums, are rapidly eroding.

The Demand for Change

If art institutions have experienced blowback from the political Right over the past decade, so too have art institutions justifiably become an object of inquiry on

the Left—we've seen outcry against institutions for accepting patronage from "problematic" sources, such as BP's patronage of the Tate and the Sacklers' patronage of the Serpentine. More scrutinized are board members (Warren Kanders of the Whitney), directors (Yana Peel of Serpentine), and even artists themselves (Dana Schutz, Erik Kessels). So, too, has the American museum landscape witnessed successful unionization efforts, such as those at the Whitney Museum of American Art, New Museum, Art Institute of Chicago, and Philadelphia Museum of Art. Many more museums have voted to unionize in 2021, with unionization efforts underway at the Jewish Museum in New York, the Brooklyn Museum, the Guggenheim Museum, and the Baltimore Museum of Art.

Like all cultural heritage institutions, art museums are often the products of decades- or centuries-old histories. They're born from outdated ideologies, comprise collections of sometimes looted or ill-begotten goods, and reflect patriarchal and Eurocentric collecting practices. Hundreds of museums throughout the world have been open and operating for over a century and boast collections of tens or even hundreds of thousands of objects, and the collections of most of these institutions comprise less than 15% of works by female artists and artists of color.[18] This means that generations of white male artists received the institution's financial support, professional

development, and accolades, while female artists and artists of color did not. One could think of this decades-long disregard as a series of failures—which, in my opinion, they are—but the question remains: If museums want to come to terms with historical missteps and exclusions and rectify their past selves, how do they do so against the backdrop of budget cuts and financial crises that predate and continue beyond the COVID-19 pandemic?

Indeed, one of the most consequential and difficult-to-rectify crises of equity facing museums today is that of representation: in the workforce, content programming, and within museum collections. At the Stedelijk Museum Amsterdam, for example, the number of works created by women in the collection is estimated to be 6%. The number of works created by people of color is currently being tallied but is estimated to be equal to or less than the amount of works made by female artists. A study titled "Diversity of Artists in Major U.S. Museums," published in March 2019 in the journal *PLOS ONE*, gathered information on the representation of women and people of color in major US museums, including the Museum of Modern Art, the San Francisco Museum of Modern Art, the Whitney Museum of American Art, the Rhode Island School of Design Museum, the National Gallery of Art, the Metropolitan Museum of Art, the Los Angeles County Museum of Art, and the Art Institute of Chicago. The results showed that the representation of women in

these museums' collections ranged from a low of 7.3% (Metropolitan Museum of Art) to a high of 22.1% (the Whitney Museum of American Art). The study takes whiteness as a category, and the National Gallery of Art had the highest quotient of white artists in their collection (97.4%), while the Los Angeles County Museum of Art and the RISD Museum of Art shared the lowest amount of white artists in their collections (78.2%).[19] It would be an interesting, if challenging, feat to examine how these numbers have changed since the accumulation of this data in 2019, as museums have made a more deliberate effort to diversify their permanent collection displays in recent years.

These disparities extend beyond the artists in the collection: if you were to consider the staff makeup of museums, particularly at the stakeholder level—that is, management, the director's office, and above—such positions overwhelmingly bypass women, people of color, LGBTQI+, and individuals living with disabilities. And if museums have recently become aware of the public's desire for broader representation, how are institutions to fulfill that wish when they are run by those with no lived experience of representational marginality? In this case, art institutions may seek to answer such demands by altering their exhibition content rather than reevaluating their ways of working. It is one thing to mount an exhibition by an artist living with a disability; it is

another step entirely to ensure that a museum's building and programs are truly accessible, whether through access ramps, captions for online talks and videos, or other forms of interpretation—to make material, rather than just representational (or tokenistic), change.

Biography

In this regard, one of the key tenets of *After Institutions* is that the field of art must consider its work not only as an abstract space for representation, but also as one in which material realities are constructed and upheld. (See Andrea Fraser's thoughts on the human makeup of "the institution" later in this text.) To that end, the industry suffers from a contradiction. We, its members, unintentionally uphold and even reproduce the oppressive systems that we critique: in the US, access to healthcare is scant or nonexistent; time off for physical or mental health is unavailable or discouraged; wheelchair accessibility is rare; overtime is uncompensated; and the bars, parties, and gallery dinners where so many professional opportunities and discoveries happen often exclude those of us with childcare responsibilities, or who abstain from alcohol. On the whole, the art world struggles with the ableism and elitism of the world at large, so often upholding rather than challenging traditional definitions

of normativity. If exhibitions and related discourse surrounding accessibility have made these themes more visible—this is only positive—it remains to be seen whether arts organizations themselves have become significantly more accessible in the same time period.

There is also the slippery yet vital question: To what degree is lived experience important in the creation of an artist's work and the contextualization surrounding it? How much should we connect the artwork to the artist? As the increasingly numerous artworks that reflect lived experiences have been inadequately represented in the art-historical timeline, an artist's biography can be vital to understanding their perspective—certainly an artist utilizing sign language in their work would be read differently depending on whether they are deaf or hearing, for example. However, biography can also be misused to cut corners in the contextualization of an artist's work, and can result in both assumptions about the artist's intentions (she made large sculptures because she was petite and felt small) and overly narrow interpretation, as, for example, when the work of trans artists and Holocaust survivors is read only through the respective lenses of gender or genocide. On the other hand, amid the backdrop of so-called cancel culture,[20] there's also an inclination to separate the art from the artist, to claim that the ethics of the artist are distinct from the morality within the work[21]—for example, to exhibit Carl Andre's

work despite knowledge that he allegedly murdered his wife Ana Mendieta, or to continue enjoying Woody Allen's films despite him marrying his step-daughter.[22] My personal sense of ethics does not allow me to do these things: consuming art and media by these makers means that they continue to exist in a system that bestows money, power, and accolades upon them. A greater understanding and more nuanced use of biography is crucial to the analysis of artwork being made against the backdrop of a more clairvoyant set of representational ethics suffusing the field of art today.

In thinking through the analysis of an artwork via biography, art historian Anna Chave's essay "Minimalism and Biography" (2000) provides an important historical touchstone.[23] She writes that biography as a critical tool of analysis is particularly useful when applied to the standard modernist vision of the artist as a singular, transcendent genius—Pablo Picasso and Jackson Pollock epitomize this mythologizing of the artist's inner life. The diminished emphasis on the private self, inherent to postmodernism, should render biography a less important tool. Moreover, the machine-produced, impersonal aesthetics of Minimalism, she argues, should underscore the detachment of art from biography. But while Minimalism purported a division between the art object and the maker, this neutrality was only afforded to a certain set of individuals—namely the white, straight,

cisgendered men who constituted the hegemonic, "universal" subject position of the time. If we consider the legacies of Robert Morris and Eva Hesse, both of whom were intellectually and socially central to Minimalism and Postminimalism, we see the uneven emphasis in their biographical treatment. As Chave explains, Hesse's "critical fortunes have all along been colored by attention to her biography," with ample credit given to a "network of enabling colleagues." Meanwhile, Morris is permitted to stand alone as a solitary genius, even if he had close relationships with, and was indeed influenced by, a litany of female artists and critics, among them Simone Forti, Yvonne Rainer, Lynda Benglis, and Rosalind Krauss.

While the orthodox read of 1960s Minimalism is that it introduced a dance between the neutral maker, unmediated art object, and neutral reader, such a framework was soon revealed as farcical. The universality of the assumed neutral viewer fails to consider the wide variations in faculties and bodily experience among individuals: the height at which we experience an artwork, to name but one example, differs greatly depending on not just our height, but whether we're standing or sitting, perhaps in a wheelchair or museum stool. Looking back at the artists of the period, Chave notes that many Minimalists developed a signature style—however removed from haptic and emotionally hewn works—that double down

on rather than rescind authorship, conferring money and prestige on select members of the canon. Further, as second-wave feminists attested in the following decades, the personal *is* undoubtedly political, and the conditions that promote confidence, the emotional capability to speak up, and the ability to make intellectual contributions are anything but neutral. As Chave writes, "For those unacculturated to the prerogatives of speaking, unused to holding the floor, anonymity is but regulation wear."[24]

There is, though, a double-bind: as useful and sometimes qualifying as biography can be, it can also entrap its user. Even if an artwork is intended to speak toward a collective experience, biography is necessarily singular. There is thus an immense amount of responsibility inherent to the contextualization of such artworks by writers, curators, and other museum workers, such as education and marketing staff. Given that nearly all blockbusters are monographic, these exhibitions and the communication around them are susceptible to mythologizing the artist's biography. Further, within wall texts, biography is often unevenly applied depending on the "neutrality" of the artist's subject position, pinning down artistic meaning on the maker's identity. The reasoning for acquisitions by makers of representational marginality, in the most tokenistic of circumstances, can be chalked up to the artist's biography.

But this is a trap into which we don't have to fall. One should question, firstly, whether biographical treatment is necessary: Is the reception of artwork serviced by knowledge of certain facts about the artist's private life, particularly if there could be a social curiosity attached to these facts? Do we need to know that this artist is transgender, for example? Is this institution divulging personal information without the artist's consent? And, secondly, can the story that this artwork is telling be connected to a collective experience that de-emphasizes the singular nature of biography? And, relatedly, can any biography found in the artwork be used to draw more general conclusions about the context it finds itself in, about the museum or gallery in which it is viewed?

1 Steffie Woolhandler et al., "Public Policy and Health in the Trump Era," *The Lancet* 397, no. 10275 (February 2021): 1, https://doi .org/10.1016/S0140-6736(20)32545-9.

2 See Robin Pogrebin and Matthew Goldstein, "Leon Black to Step Down as MoMA Chairman," *The New York Times*, March 27, 2021, section A, 19.

3 See Sarah Cascone, "In a Landmark Move, the Metropolitan Museum of Art Has Removed the Sackler Name from Its Walls," *Artnet News*, December 9, 2021, https://news.artnet.com/art-world/met -museum-removing-sackler-name-2046380.

4 In the Dutch landscape, an interesting takedown of blockbusters was written by Museum de Lakenhal director Meta Knol after that museum's February 2020 Rembrandt blockbuster exhibition. Knol wrote that such exhibitions are plagued by high insurance and loan courier costs, which drives up ticket prices, limiting who can see these exhibitions, while stressing small staffs and not necessarily making a significant return, if any, for these blockbusters.

5 National Gallery of Art, "Treasures of Tutankhamun," NGA (website), https://www.nga.gov/exhibitions/1976/tutankhamun _treasures.html.

6 Association of Art Museum Directors, "Association of Art Museum Directors' Board of Trustees Approves Resolution to Provide Additional Financial Flexibility to Art Museums during Pandemic Crisis," April 15, 2020.

7 Robin Pogrebin, "Brooklyn Museum to Sell 12 Works as Pandemic Changes the Rules," *The New York Times*, September 17, 2020, section C, 1.

8 Maxwell L. Anderson et al., "Letter to the Baltimore Museum of Art," *Artnet News*, October 28, 2020, https://news.artnet.com/app/news -upload/2020/10/Letter-to-the-Baltimore-Museum-of-Art.pdf.

9 See Sarah Cascone, "Two Baltimore Museum Trustees Resign and Donors Rescind $50 Million in Gifts as the Institution Prepares to Sell Off Blue-Chip Art," Artnet News, October 26, 2020, https://news.artnet.com/art-world/baltimore-donors-rescind-50 -million-gifts-1918139.

10 Nancy Kenney, "Members of US Museums Association Narrowly Reject Proposal to Contemplate a Change in Guidelines on Art Sales," *The Art Newspaper*, March 16, 2021, https://www .theartnewspaper.com/2021/03/16/members-of-us-museums -association-narrowly-reject-proposal-to-contemplate-a-change -in-guidelines-on-art-sales.

11 Arjen Ribbens, "Red de Amsterdamse cultuur, verkoop een Roy Lichtenstein," *NRC*, February 8, 2021, https://www.nrc.nl /nieuws/2021/02/08/red-de-amsterdamse-cultuur-verkoop-een -roy-lichtenstein-a4030971.

12 Dorian Batycka, "Poland's Ministry of Culture Again Accused of Trying to Control Progressive Institution," *Hyperallergic*, September 24, 2019, https://hyperallergic.com/518207/polands-ministry-of- culture-again-accused-of-trying-to-control-progressive-institution/.

13 Alex Marshall, "A Populist Leader Kicks off a Culture War, Starting in Museums," *The New York Times*, January 29, 2021, section A, 12.

14 Dorian Batycka, "Populist Leaders in Central and Eastern Have a New Target in Their Fight Against Liberalism: Art Museum Directors," *Artnet News*, February 8, 2021, https://news.artnet.com /art-world/culture-war-central-europe-1941897.

15 Eurostat, "Cultural Employment 2020," in *Culture Statistics*, May 2021, https://ec.europa.eu/eurostat/statistics-explained /index.php?title=Culture_statistics_-_cultural_employment.

16 Eurostat, "Mining and Quarrying Statistics," in *Business Economy by Sector*, June 2021, https://ec.europa.eu/eurostat/statistics-explained/index.php/Mining_and_quarrying_statistics_-_NACE_Rev._2.

17 US Bureau of Economic Analysis, *Arts and Culture Economic Activity 2020*, last modified March 15, 2022, https://www.bea.gov/data/special-topics/arts-and-culture.

18 Chad M. Topaz et al., "Diversity of Artists in Major U.S. Museums," *PLOS One* 14, no. 3 (March 2019), doi: 10.1371/journal.pone.0212852.

19 Ibid., table 2.

20 Cancel culture, to me, is a term that arose in popularity with those people sensing a loss in power amid the social justice movement. It is the only socially acceptable phrasing to cast suspicion on those who object to abuses of power.

21 See Noël Carroll, "How Should We Relate to the Work of 'Cancelled' Artists?," *The New Statesman*, February 2, 2021, https://www.newstatesman.com/international-politics/2021/02/how-should-we-relate-work-cancelled-artists.

22 See Claire Dederer, "What Do We Do with the Art of Monstrous Men?" *The Paris Review*, November 20, 2017, https://www.theparisreview.org/blog/2017/11/20/art-monstrous-men/.

23 Anna C. Chave, "Minimalism and Biography," *The Art Bulletin* 82, no. 1 (March 2000), https://doi.org/10.2307/3051368.

24 Ibid., 158.

II
Institutional
Critique

The issues that I've outlined here connect art and institutions to broader political, economic, and social phenomena. And while art as a field and discipline is no doubt connected to these societal forces, the question remains: How are these concerns expressed within art itself? Institutional Critique, and more broadly art that reflects upon and critiques institutions, are both uniquely suited to reflect on issues relating to governance, health, representation, and justice. Such works can draw meaningful connections between art and life. Pitched as an exhibition examining the current state of Institutional Critique, *After Institutions* sought to bring together many of the contemporary artists who are consciously working in, referencing, and expanding this canon, which itself can be read as exclusive. My research for the exhibition prompted me to think of Institutional Critique as

occurring in three waves, spanning over sixty years of history—from the late 1960s to today—with each wave reflecting its own social, economic, and historical contexts, as well as its own set of artists who all have their own strategies, concerns, and goals. In tandem with these shifting priorities, the definition of Institutional Critique and its notions of site and aesthetics continues to evolve throughout. And while the structure of "waves" may be a useful imposition upon these artists' work, it is also true that an artist could be working during one wave and not be recognized until, and thus would largely be associated with, a subsequent wave. Nonetheless, this rubric provides a foundation through which we can consider the evolution of Institutional Critique.

First-Wave Institutional Critique

With all of the ethical challenges at play within the field of art over the past sixty years, it would be no surprise if Institutional Critique had arisen specifically to function as a watchdog. But this is decidedly not the case. Institutional Critique first coalesced as an extension of Conceptual Art, and within this purview the rejection of the commodity status of art was imperative. As such, Institutional Critique embraced an anti-aesthetic that rejected the vestiges of visual representation. Later

generations associated with Institutional Critique, such as artists linked with the Whitney Independent Study Program, Pat Hearn, and American Fine Arts, Co. galleries in New York in the late 1980s and 1990s, took a comparatively more activist approach and arguably reintroduced visuality into their work. This activist engagement with social issues can be seen in the most recent wave of artists associated with Institutional Critique, which also marks a partial return to a visuality that was originally spurned by the 1960s–70s wave. Of course, some gatekeepers of Institutional Critique would argue that art that engages the visual, particularly craft-based and haptic works, categorically cannot be considered Institutional Critique because it uncritically commodifies itself, circumventing an anti-aesthetic strategy. In other words, such work is not Institutional Critique but simply artwork about institutions. This is a paradigm from which I respectfully diverge. Rather, I attempt to open up the definition of Institutional Critique—particularly for art being made today, and relevant historical work made outside the Western framework of Conceptual Art—as existing on a spectrum of visual and cognitive experience. While it would seem unwitting of the history before it, this approach suggests that the visual artistic object is not tantamount to a contradiction, but simply emblematic of what it is: a form of aesthetic communication.

Mel Bochner, *Working Drawings and Other Visible Things on Paper Not Necessarily Meant to Be Viewed as Art*, 1966

In order to grasp the discourse surrounding what is and is not Institutional Critique today, and the stakes surrounding its definition, it is vital to understand its beginnings. Benjamin H. D. Buchloh's landmark text "Conceptual Art 1962–1969: From the Aesthetic of Administration to the Critique of Institutions" (1990),[1] outlines the various, often divergent approaches of artists associated with Conceptual Art and their aims to emancipate art from the primacy of visual representation. These artists reframed what is and isn't shown in an exhibition space, and thus what is considered art. For

example, Mel Bochner's exhibition *Working Drawings and Other Visible Things on Paper Not Necessarily Meant to Be Viewed as Art*, held at the School of Visual Arts in 1966, exhibited ideas on paper with no visual element. Similarly, in 1968, Seth Siegelaub published an exhibition in the form of a book titled *The Xerox Book*. This turn toward a purely conceptual presentation (in this case a purely textual presentation) placed the realm of ideas over the visual, and as such challenged every preconceived notion of art at that moment: from how to experience artwork in a gallery to how to collect it.

More specifically, artists of this period worked through the form of the cube in reference to the architectural backdrop of the gallery space. Hans Haacke's (*1936) *Condensation Cube*, a Plexiglas cube filled with condensation that collects and disperses based on the environmental conditions of the gallery, connects the art object to architectural space and the presence of the viewer. The changes within the cube, and their organic nature, highlight the metaphorical "aliveness" of the museum, and its status as a living, breathing system made up of the beings that inhabit it.

Lawrence Weiner (1942–2021) also makes use of the square in his "removal" works, such as *A Square Removal from a Rug in Use* (1968). In these works, the artist extracts a portion of a rug in the gallery space and places it on the wall. While both Haacke and Weiner's works reference the specificity of the site surrounding them, to

Buchloh, Weiner's "removal" works represent a conceptual purity in that they add no additional visual material to the aesthetic experience, but rather reference only pre-existing elements within the gallery itself. This action both challenges the purported need for visual representation in an artwork and also opens up the content of the work to a reflection on the exhibition space and institution themselves. Beginning with this site-specific nod toward the institution's architecture, Weiner critiques the metaphorical and literal "institution," both the set of socially prescribed rules governing artistic practice and the set of political and economic forces that determines an artwork's value.[2]

In a similar vein, Buchloh recognizes that an artwork's appearance and its facture, or appearance of how it is made, are not just aesthetic qualities to be judged through the viewer's experience, but traces of institutional power and ideological and economic investment. In the late 1960s, European artists such as Marcel Broodthaers (1924–1976) and Daniel Buren (*1938), as well as Haacke, likewise recognized the ideological apparatus of institutional power. While work from this period is sometimes seen as less "political" than that of artists from forthcoming generations, their politics were very much present, but played out via the white cube. It should be noted, too, that Broodthaers is here an outlier, as his work is, paradoxically, *decidedly* visual. One of his

Lawrence Weiner, *A SQUARE REMOVAL FROM A RUG IN USE*, 1969

best-known installations is even titled *Décor: A Conquest by Marcel Broodthaers* (1975) and takes the form of period rooms from the nineteenth and twentieth centuries filled with disconsonant curiosities, such as various battle canons, guns, a patio furniture set, and a preserved crab and lobster playing cards. Originally installed at the Institute of Contemporary Arts in London, the exhibition was set to coincide with the annual Trooping the Color military parade on the Mall and was thus infused with representation of military and state prowess.

Notably, Buchloh never uses the term "Institutional Critique." Writing in 2005, Andrea Fraser notes that artists such as Broodthaers, Buren, and Haacke also never used the term to describe their own practices. It wasn't until 1985, in Fraser's essay "In and Out of Place," that the term "Institutional Critique" first appeared in print— though, as Fraser recalls, the term seems to have been in the air before that, possibly used in seminar discussions with the art critic Craig Owens or Buchloh himself.

Hazarding a definition for and recognizing the significance of an artistic movement necessitates a certain distance from it. Writing fifteen years after Buchloh's essay, Fraser's texts "From the Critique of Institutions to an Institution of Critique" (originally published in *Artforum* in 2005) and "What is Institutional Critique?" (2006), reflect on the history, parameters, contradictions, and core tasks of the art associated with this movement. Published just a few years before the Great Recession of 2007–09, Fraser writes with a politically, economically, and socially engaged focus, conscious of the neoliberal economic model's indelible mark on not just the art market, but also museums and artistic practice.

Fraser pays particular attention to a work by Michael Asher, for which he brought his roving caravan trailer to Skulptur Projekte Münster (1977). To Fraser, the work demonstrates that this everyday object is only

recognizable as art through the framing around it.[3] As anyone who has gone to Münster for the Skulptur Projekte would attest, finding art throughout the city is difficult, and Asher's project is no exception—it really is "just" a trailer, moved once every ten years for each edition of the show. Yet in terms of the art object itself, as Fraser points out, Asher takes the readymade into total banality: while Marcel Duchamp's assisted readymades were manufactured objects that were either modified or juxtaposed with other mass-made objects, and shown within an institutional setting, Asher's caravan was not modified in the slightest and shown in the *plein air* of a Münster parking lot.

Fraser further distinguishes Institutional Critique works from Conceptual Art by specifically defining its critical reflexivity and site-specificity, embodied in works such as Asher's, and thus embeds Institutional Critique in social engagement over purely formal and spatial engagement. Fraser defines Institutional Critique as a methodology, which could open its application to contexts other than simply the production of artworks. She writes:

> Institutional Critique can only be defined by a
> methodology of *critically reflexive site-specificity*.
> As such it can be distinguished first of all from
> site-specific practices that deal primarily with

the physical, formal, and architectural aspects of places and spaces. Institutional Critique engages sites above all as social sites, structured sets of relations that are fundamentally social relations.[4]

Fraser's addition of social engagement is particularly clarifying, as site-specificity, in works from the 1950s–70s, had been focused on leaving the gallery—consider, for example, Happenings and Land Art. The work of the first wave of Institutional Critique was the first to return to the locus of the exhibition space so as to analyze the institution itself.

Epitomizing the social dimension of Institutional Critique is the work of Hans Haacke, who was arguably the only activist artist in the first wave of Institutional Critique. He came to Institutional Critique through his 1960s works that reflected on physical and environmental systems; he later expanded his scope to encompass social systems through such projects as his gallery visitor polls in the late 1960s and early 1970s. These works requested visitors' biographical information and asked them questions on various sociopolitical issues; sometimes the questions seemed in conflict with museum stakeholders. Haacke's *MoMA Poll* (1970), for example, asked visitors about erstwhile MoMA board member and New York State Governor Nelson Rockefeller: "Would

the fact that Governor Rockefeller has not denounced President Nixon's Indochina Policy be a reason for your not voting for him in November?" Likewise, *Gallery-Goers' Birthplace and Residence Profile, Part 1* (1969), first staged at Howard Wise Gallery, displayed a series of maps and asked visitors to mark their birthplace with red pins and their current place of residence with blue pins. The results of the poll were immediately available to gallery-goers, which revealed that the art-going constituency primarily came from the more wealthy, elite parts of Manhattan. Haacke thus laid bare how access to arts and culture is often limited by socioeconomic factors, yet, within the discourse in the field of art, access to it is erroneously seen as public and open. As Haacke states in the audio guide for his 2019 New Museum retrospective: "I believe it is important for the visitors to recognize and to watch the social setting they belong to and how much they have in common and not in common with their peers, so that they know what this is—this social environment which they inhabit."[5]

Thus, Haacke is among the first artists to engage the institution as not just an environment and architectural container, but as a site in which political, social, and economic interests are entangled. His works, like those of many artists working within Institutional Critique in the subsequent decades, strive not necessarily to dismantle the institution out of a revolutionary impulse, but rather

to make visible the unseen pressures that shape it, to hold it accountable, and to increase the transparency of its operations.[6]

And then there's an uncanny caveat: if you're in the fortunate position of being able to meet the art legends of the 1960s and 1970s, they don't always fit the picture that we imagine for them. Take, for example, New Museum Union organizer Dana Kopel's description of meeting Haacke in advance of his 2019 retrospective at the New Museum. While he sympathized with the union's efforts and had been involved in the unionization of Cooper Union staff himself, he would only support a potential strike *after* the opening of his own exhibition, thus denying the union of any leverage in negotiations with museum management.

While I am grateful Kopel published this account, I wonder what Haacke thinks of this story himself. Further, this characterization of Haacke doesn't exactly square with my understanding of him as I got to know the artist amid preparatory talks for *After Institutions*, which also took place in 2019 shortly after the opening of *All Connected*. Rather, I found him to be both measured and slightly cantankerous, not unpleasant but not overly concerned about relationship management with the contemporary art curator of a large European institution. He was insistent that any new work he would make for *After Institutions* must be the product of a lengthy research

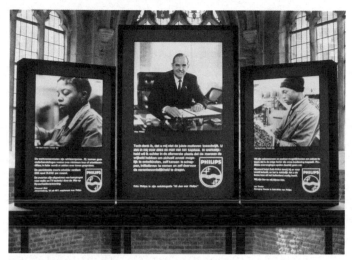

Hans Haacke, *Toch denk ik, dat U mij niet de juiste motieven toeschrijft* (But I Think You Question My Motives), 1978–79

process and respond to the Dutch political context. In other words, he couldn't just whip up a *Visitor Poll* for us in a few months. He also hated the idea of bringing in the Stedelijk's collection piece, *Condensation Cube*, into the exhibition, even if it's widely considered a work of proto-Institutional Critique. He also wondered how a piece he made about the labor exploitation of Black South Africans by the Dutch global corporation Philips (*Toch denk ik, dat U mij niet de juiste motieven toeschrijft*)

[But I Think You Question My Motives] (1978–79) would be received by the Dutch today, and whether its exhibition may spur negative attention from politicians.

In my opinion, Haacke made a mistake in not maximizing the leverage of the New Museum Union. Yet historically, Haacke's oeuvre highlights how works of contemporary art—and Institutional Critique in particular—can insert themselves into an expanded field of relations, and one mistake doesn't annul that contribution. In the instance of *Toch denk ik ...*, the object of critique is not the art museum, but rather a corporation's colonial expansion and their bias against Black workers. And despite Haacke's misjudgment with the New Museum Union, his work has long underscored that the art world itself is governed by the same material realities that it critiques.

With this in mind, it is evident that the psychological separation of the field of art from material reality is a damaging one—and it is a generations-long tenet of Institutional Critique to connect the two in artistic discourse. Fraser writes about this harmful imaginary distance between the field of art and material reality in 2005:

Representations of the "art world" as distinct from the "real world," like representations of the "institution" as discrete and separate from "us,"

serve specific functions in art discourse. They maintain an imaginary distance between the social and economic interests we invest in through our activities and the euphemized artistic, intellectual, and even political "interests" (or disinterest) that provide those activities with content and justify their existence.... Every time we speak of the "institution" as other than "us," we disavow our role in the creation and perpetuation of its conditions.[7]

While most definitions and the discourse around Institutional Critique tend to focus on the institution as its object, Fraser's definition departs from this in two ways: firstly, she posits Institutional Critique as a methodology that can be ascribed to contexts outside of art institutions, and, secondly, she pays special attention to the artist's role in producing commodifiable work as an object of critique. This underscores Fraser's belief that the person who critiques, within Institutional Critique, is acting from an internal rather than external position. In fact, one of the first essays of Institutional Critique, by Daniel Buren, was on the function of the artist's studio and suggested that artists are active participants that supply and make up the institution.[8] Fraser, in turn, quotes Haacke: "Artists, as much as their supporters and their enemies no matter of what ideological coloration, are unwitting partners.... They participate jointly in the maintenance

and/or development of the ideological make-up of their society. They work within that frame, set the frame, and are being framed."[9]

Building on Haacke's point, Fraser's central thesis is that, in order to increase transparency and accountability, art's constituents must recognize that "we" make up the institution. She writes, "It's not a question of being against the institution: We are the institution. It's a question of what kind of institution we are…because the institution of art is internalized, embodied, and performed by individuals, these are the questions that institutional critique demands we ask, above all, of ourselves." This brings to mind the *critically reflexive* component of Fraser's *critically reflexive site-specific* methodology defining Institutional Critique: that artists must be critically self-aware in their participation in the field.

Having already been in conversation with Fraser for *After Institutions*, I interviewed her for the volume *The Art of Critique*, published on the occasion of the partially canceled Frans Hals Museum project curated by Melanie Bühler. In the interview, we speak about squaring the history of Institutional Critique with its broader understanding today. She states, "Conceptual Art influences certainly are important to how I understand Institutional Critique as an artistic practice. And the most important component of that for me is the anti-aesthetic aesthetic critique of the art commodity."[10] Other works

and actions are thus simply artworks about institutions, but not necessarily Institutional Critique. This is a sentiment that I have heard from several other editors, curators, and museum directors over the four-year course of my research.

Fraser's own practice exemplifies these principles. In both her early works, such as *Museum Highlights: A Gallery Talk* (1989), a staged performance as a gallery docent, as well as her more recent research-driven essays ("L'1% C'est Moi" [2011], "There's No Place Like Home" [2012]) and publications such as *2016 in Museums Money and Politics* (2018), which outlines political campaign contributions made by museum board members in the year of Donald Trump's presidential election, Fraser locates the discourse around art as a site of analysis. Critical self-reflexivity in this instance is the consciousness of the material impact that the work creates. The easy commodification of a work, to Fraser, would not entail a critical reflexivity—and to this day, Fraser's rubric defining Institutional Critique for herself still necessitates that a work employs an anti-aesthetic strategy to properly qualify within this canon.

While Fraser is, to me, the most influential and studied voice defining Institutional Critique, and she has clearly stated that she is not invested in gatekeeping what is or is not to be considered Institutional Critique, I diverge from her own definition and argue for the expansion of it. To open up Institutional Critique to interpretations

beyond works employing an anti-aesthetic strategy is to seek new interpretations of institutions, to look beyond what cultural institutions were to what they are and what they might be. And as I write in the next section on the second wave of Institutional Critique, of which Fraser was a part, it is increasingly difficult to discern which works actually employ an anti-aesthetic strategy, and to what extent this affects this generation's relationship to its sense of ethics, professional practice, and activism.

Second-Wave Institutional Critique

The 1960s saw a period of prosperous economic conditions, while the 1970s experienced a period of "stagflation." Under the presidency of Lyndon Johnson (in office from 1963–69), the United States saw the expansions of labor protections, civil rights, and the welfare state, while the number of Americans living in poverty decreased from forty million to twenty-four million people between 1961 and 1969. The welfare state of this period was not just alive, but flourishing, and stands in marked distinction to that of a decade later, beginning after the introduction of austerity measures and neoliberal economic policies by the Carter and Reagan administrations in the United States, and the Thatcher government in the United Kingdom.

It is in this period—during the rise of neoliberalism in the late 1980s and early 1990s—that the second wave of Institutional Critique began. This period was also marked by a health crisis of its own: that of AIDS. The artists commonly associated with this wave were mostly based in New York. Many of them attended the Whitney Independent Study Program in 1989 and found a home at the galleries American Fine Arts, Co. and Pat Hearn. Many participated in the 1993 James Meyer–curated exhibition *What Happened to the Institutional Critique*, at American Fine Arts, Co., which included artists such as Gregg Bordowitz (*1964), Tom Burr (*1963), Mark Dion (*1961) and the Chicago Urban Ecology Action Group, Andrea Fraser (*1965), Renée Green (*1959), Zoe Leonard (*1961), and Christian Philipp Müller (*1957). Meyer's exhibition was complemented by a landmark essay of the same title. In it, he lays out a genealogy and framework for thinking through how artists of his generation were utilizing, building on, and departing from the definitions of Institutional Critique developed a generation before.

The AIDS crisis devastated this community, claiming the lives of friends and mentors such as Craig Owens (1950–1990), Peter Hujar (1934–1987), David Wojnarowicz (1954–1992), and Felix Gonzalez-Torres (1957–1996). These losses, and the urgency to prevent further loss, became the backdrop for Meyer's thinking on Institutional Critique. The formalism associated with the

site-specificity of the first wave of Institutional Critique no longer seemed sufficient. Yet the prevalent artworks of the time, as evidenced by the 1993 Whitney Biennial, engaged what Meyer calls "identity politics."[11] To Meyer, the biennial curators (Thelma Golden, John G. Hanhardt, Lisa Phillips, and Elisabeth Sussman) contextualized artworks to thematize difference rather than engaging in an actual politics. For example, Byron Kim's *Synecdoche* series brings together monochromes of various skin colors, placing them in wall-hung grids. But does this actually challenge racial inequity? Unfortunately not.

In dealing with the omnipresence of loss and the incongruence of the neatly politicized and commodified works of this moment, Meyer found relief and inspiration in the works and words of artist and activist Gregg Bordowitz. As a video artist, Bordowitz's work was equally at home at an LGBTQI+ health center as in a gallery space. Like Zoe Leonard, he was involved in the collective DIVA TV, an affinity group within ACT UP (AIDS Coalition to Unleash Power). DIVA TV utilized the medium of video for its reproducibility and inherent ease of distribution and enacted what Bordowitz referred to as "coalition building" for AIDS awareness. In an interview, Douglas Crimp asks Bordowitz for his thoughts on Institutional Critique, and Bordowitz points to the futile formalism associated with the first generation:

The kind of work that I do now doesn't necessarily address issues of institutional critique directly but it does indirectly.... I have no more questions about gallery walls. The kind of academic understanding I used to have about institutional critique led to a dead end. It ate its own tail in its formalism. What seems useful to me now is to go out and do work that is directly engaged, that is productive—to produce work that enables people to see what they are doing, that enables them to criticize what they are doing, and moves on.[12]

Meyer notes that, in addition to its activist element, this second wave departs from the first by looking further back to the genesis of the institution itself. The art museum is preceded by the natural history museum, and the natural history museum by cabinets of curiosity. This era of institutions most directly reflects the museum's Eurocentric, colonial roots in exploration, the study of "other cultures," and the collection of artifacts and objects representing these ventures.[13] Meyer references artist Mark Dion's work, particularly his performance and installation *The Department of Marine Animal Identification of the City of New York (Chinatown Division)* (1992), in which he sorts fish, crustaceans, and other sea life found within New York's Chinatown district into taxonomical systems. In this performance, Dion mimics both the

function of the scientist in the creation of classifications and production of knowledge, and also that of the natural history museum, in translating these classifications into a display of that knowledge to the public. Meyer writes that Dion thus becomes both the museum and a site himself.

While not included in the Meyer exhibition, Fred Wilson's performance *My Life As a Dog* (1992) similarly enacts the social architectures upheld in museum space. For this piece, Wilson greeted a group of docents in the lobby of the Whitney Museum before he was to give them a tour of the exhibition upstairs. He politely excused himself and directed them to meet him in the gallery. Wilson then, however, put on a guard's uniform and stood where a guard would as he watched the docents search the galleries for him. Posing a guard made Wilson invisible to the docents. This piece highlights that the public-facing staff of a museum—namely security guards and ticket desk attendants—often account for the most people of color in many museums, yet they're sequestered physically and figuratively from the decision-making staff on the office floors. Given how unpredictable the public can act in institutions, including theft and damage of artwork and harassment of staff (take for example the March 2022 stabbing of two MoMA front desk employees),[14] this constituency is also the most vulnerable.

The first wave of Institutional Critique focused on the formal and phenomenological aspects of sites understood as physical places, whereas the work of this second wave represents an expansion of site (the institution) with which the first wave worked. The site of the second wave looked back at the genesis of the institution in order to analyze how institutions function and continue to produce public knowledge—art museums, Meyer notes, adopted the same taxonomical systems first employed by natural history museums. Thus, it is the production and institutionalization of knowledge itself, and by extension the entire field, that became a site for the second wave.

Along with lamenting a certain breed of artwork that thematizes rather than enacts politics, Meyer also problematizes artists who were formerly seen as politically aware, such as Barbara Kruger and Sherrie Levine, and who started working with commercial galleries that show "neoconservative" artists such as David Salle and Julian Schnabel. This echoes his skepticism toward Byron Kim's overtly aesthetic, traditionally saleable work, and also Andrea Fraser's insistence on the importance of an anti-aesthetic strategy. Taken together, Fraser and Meyer's concerns speak to the desire of this generation to critique not just the art commodity, but more generally the uncritical participation in the capitalist infrastructure that produces the conditions against which such artists protest.

While these principles are laudable, I wonder if this is an ethical framework that can or should be applied to the contemporary conditions artists contend with today. Certainly, today we can be critically aware of the conditions within which we work. But, returning Daniel Buren's seminal text of Institutional Critique,[15] the space of the artist's studio can be critiqued as a site of the architecture of capitalism. Yet who, in our contemporary world of overpriced real estate and widespread financial precarity, would relinquish an affordable studio for ethical considerations? That would be viewed as insanity. There is, after all, a material reality that we're seeking to make sense of within the canon of Institutional Critique. This question had erstwhile divided artists in the 1980s and 1990s, and its relevance continues today: How far should our ethics extend when evaluating whether to participate in the art market and capitalism? To what extent can I be simultaneously ethical and practical? At this point, it's easier to imagine the end of the world than the end of capitalism.[16]

These questions lead into another: Did all of the works associated with this second generation actually spurn visuality? Mark Dion's works are exhaustive in their detail and decor, often parodying the form of cabinets of curiosity and natural history museum displays. Zoe Leonard's work is also extremely pictorial in comparison to that of Haacke and Weiner. Her series *Tree + Fence*

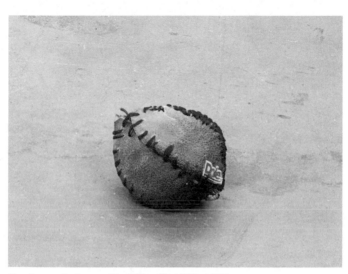

Zoe Leonard, *Strange Fruit* (detail), 1992–1997

photographs trees whose growth has over years spilled into city fences, a metaphor for flourishing in urban confinement. In addition to Leonard's *Tree + Fence* series, we were in conversation about showing her lesser-known series *Trophies* (1990), photographs of preserved animal heads acting as hunting trophies; a work from *Carnivores* (1992/1997); as well as several works from *Police Museum*, a series that photographs guns, fisticuffs, and other police material on exhibition.

Zoe Leonard, *Strange Fruit*, 1992–1997

In contradistinction to the theme of survival in *Tree + Fence* but echoing her photographs of taxidermy, Leonard's *Strange Fruit* (1992–97), made in the wake of the death of her friend David Wojnarowicz, features fresh fruit that has been ripped open, eaten, its hollow peels sewn back together, scattered around a gallery floor, and allowed to desiccate through the life of the work—a metaphor for the body ravaged by AIDS and left behind by society. Although *Strange Fruit* may not immediately read as

Institutional Critique, the work critiques two institutional systems: the ephemeral nature of the conceptual apparatus of the work—fruit skins left to rot with no allowed conservation intervention—challenges the preservation and collecting functions of the museum.[17] Secondly, Leonard confronts the American medical system as an institution that failed those afflicted with AIDS and posits the medical industry as an expanded site. *Strange Fruit* takes its title from a 1937 anti-lynching protest song by Abel Meeropol (which was popularized by Billie Holiday), and the work developed incidentally after the artist began sewing fruit after eating it at meals as a solitary activity of mourning. Leonard, whose work was slated to be shown throughout *After Institutions*, is an artist whose work forms both the core and peripheries of this wave and is helpful when thinking about the parameters of Institutional Critique.

Discursive Sites and Exhibition Methodology

One of the goals of *After Institutions* was to expand our idea of what the critique of institutions could consist of, and specifically challenge what we expect Institutional Critique to look like—bringing works inspired by Conceptual Art and employing an anti-aesthetic strategy in

conversation with representational, narrative, and pictorial works. This clearly represents a departure from the rubrics for Institutional Critique set out by Buchloh, Fraser, and Meyer—but I wonder to what extent those frameworks must shift in connection with how society has evolved in the past decades since their writing. While a work's content must still be aware of the conditions of its making, no longer does a formal site-specificity, or even the genealogical investigation of institutions, feel urgent. In her 2002 book *One Place After Another: Site-Specific Art and Locational Identity*, art historian Miwon Kwon theorized that a site could also be a discursive subject:

> Current forms of site-oriented art, which readily take up social issues (often inspired by them), and which routinely engage the collaborative participation of audience groups for the conceptualization and production of the work, are seen as a means to strengthen art's capacity to penetrate the sociopolitical organization of contemporary life with greater impact and meaning. In this sense the chance to conceive the site as something more than a place—as repressed ethnic history, a political cause, a disenfranchised social group—is an important conceptual leap in redefining the public role of art and artists.[18]

If one were to consider Kwon's notion of the discursive site and pair it with Fraser's definition of critically reflexive site-specificity, a new world opens for Institutional Critique. Art historians and theorists have certainly undertaken this pursuit in the past, as well. Gerald Raunig's essay "Instituent Practices: Fleeing, Instituting, Transforming" (2006) [19] argues that Institutional Critique should not be paralyzed by its originating rules and must continue to develop in tandem with society as a critical attitude, which he names "instituent practices." Raunig suggests expanding the definition of Institutional Critique by considering and historicizing the act of critique itself. He locates the origin of critique in the development of governmentalization in Europe in the sixteenth century. Raunig quotes Michel Foucault's lecture "What is Critique" (1978), describing the subject's desire not for anarchy, but to not be governed in a certain way, to not be governed *like that*, by that, in the name of those principles, with such and such an objective in mind and by means of such procedures, not like that, not for that, not by them."[20] Thus, it is the way that we are governed, and not the fact that we are governed, that is what gave rise to our first collective experiences of critique. Given that institutions are born out of and function as expressions of the state, Institutional Critique could be thought of as an extension of this critique on governance. This broadening of the scope of Institutional Critique

65

continues the expansion of site begun by the second wave generation and could include formal institutions created by entities such as the government and public, state-sanctioned services such as healthcare, the judicial and prison system, military, property ownership, education system, etc. This more expansive definition of Institutional Critique could be a step toward broadening the understanding of contemporary art and its entanglements with governance, helping us to foreground artworks and practices that seek to effect change on the material—rather than strictly symbolic—level.

After Institutions comprised works that employ a wide array of aesthetic strategies and definitions of the institution. The introductory room of the exhibition was slated to feature a work from the Stedelijk collection by Mario García Torres (*1975), an artist who is long considered to be working in the vein of Institutional Critique. His piece *Preliminary Sketches from the Past and for the Future (Stedelijk Museum)* (2007) comprises five slide projections of images capturing the artist and a cohort of performers exploring the Stedelijk amid its lengthy closure and renovation process from 2004–12. In the slides, the performers run and bicycle through galleries, jump off walls, and perform other gestural studies (as García Torres refers to them), testing their bodies in relation to the space.[21] The year the piece was made was initially the target date for the museum's reopening—but as García

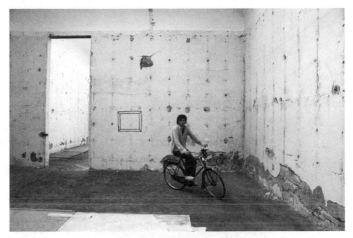

Mario García Torres, *Preliminary Sketches from the Past and for the Future (Stedelijk Museum)*, 2007

Torres's work shows, the project had been delayed, and the museum still looked like a stripped-down, bombed-out ruin. In the Dutch cultural memory, these eight years of construction extensions and setbacks, which coincided with the closure of the neighboring Rijksmuseum from 2003–12, was one of national frustration and even embarrassment. Moreover, in 2006, the Stedelijk was also transformed from a totally public institution to a hybrid one—a private foundation accountable to a supervisory board with the city of Amsterdam as its landlord and

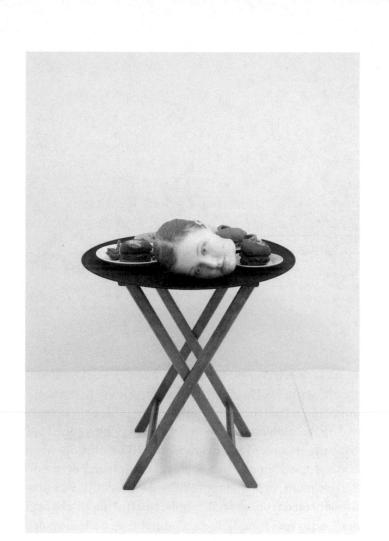

Josh Kline, *15% Service (Applebee's Waitress' Head)*, 2018

biggest sponsor.[22] García Torres's work immortalized this moment of institutional failure and transformation and set the tone of *After Institutions*—slated to open in 2020, the museum's 125th anniversary year—as one of critical self-reflection.[23]

Toward this end, the second room of *After Institutions* introduced sculptural and video works by New York–based artist Josh Kline (*1979). These pieces could hardly be associated with Institutional Critique by any measure, and yet they set the stage for the visitor, prompting the audience to consider economic precarity and the systems that sustain it. His video *Applebee's Waitress Interview* (2016–18) interviews Jenn, an Applebee's waitress, about her wages ($2.13 per hour, the US minimum wage for tip-based income).[24] With tips, this amounts to about $1,400 a month. Kline proceeds to ask her whether she has health insurance (she doesn't), her educational background (she dropped out of high school), what she ideally wants to do in life (she's a writer), and whether she will stay at Applebee's (she probably will). Complementing the video is a sculptural portrait of Jenn. Kline incorporated Jenn's narrative into *15% Service (Applebee's Waitress' Head)* (2018), which comprises full-color photographic 3-D prints of Applebee's entrees—as well as Jenn's disembodied head—placed upon a serving tray on a stand. Within *After Institutions*, these works were to be shown alongside another sculpture from the series

Blue Collars: a janitor cart, a familiar sight circulating the museum, carrying the neatly dismembered, 3-D-printed body parts of the janitor himself. As a conceptual gesture in reference to the first wave, Kline reframes what already exists in the museum but, departing from the work of Weiner, reintroduces these elements in the form of objects. Many of Kline's works put on view the lived effects of the neoliberal economy and austerity politics. For example, his installation *Unemployment* at Fondazione Sandretto Re Rebaudengo reflects on the dwindling middle class in the West, with a series of 3-D scans of individuals who have lost their jobs due to automation. Curled up in the fetal position and wrapped in plastic bags, these figures lie on the floor next to shopping carts full of plastic bottles. In *After Institutions*, Kline's work prompted the viewer to ask: Do I know anyone who has been—or will I eventually be—left behind by society? And to what, then, will I have as recourse?

The work of Isa Genzken (*1948) was also to be employed within the exhibition to stretch our definition of Institutional Critique. Her ongoing series *Ohr* (Ear), begun in 1981, is part anatomical study, comprising close-up photographs of ears—some pierced, some ringed by hair. Like many of her bodies of work, Genzken treats this content in many different styles: she prints the ears as color photographs for the exhibition space, blows them up to hang on institutional building façades, and

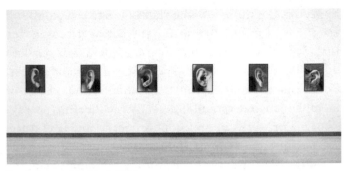

Isa Genzken, *Ohr (Ear)*, 1980

creates architectural models of the ear photos festooned upon buildings. Drawing upon the ear's biological function as a filter between the body and the outside world, Genzken positions the organ as a metaphorical membrane that highlights the institution's mediation between art and society. Further, an ear adorning an institutional building suggests, well, that it's listening, and recapitulates the social murmurings surrounding it upon its gallery walls.[25]

Further drawing on metaphor and of utmost influence to my thinking for the exhibition *After Institutions* is Susan Sontag's landmark work of critical theory, *Illness as Metaphor*, published in 1978. In its companion book *AIDS and its Metaphors* (1989), she defines her use of metaphor along Aristotle's definition: "Metaphor consists

in giving the thing a name that belongs to something else."[26] An ear substitutes for the act of listening, for instance. While Zoe Leonard's use of metaphor services our understanding of the experience of loss and illness, Sontag is decidedly against the unconscious usage of metaphor to understand illness. By recollecting passages of major works in philosophy, poetry, and literature, she outlines the feelings commonly associated with the paradigmatic diseases of the nineteenth and twentieth centuries. These feelings make up a mythology created from a collective social need to cope with the devastation of these illnesses. Tuberculosis—once known as consumption—and cancer, were both understood as diseases caused by the repression of passion, which prompted the body to consume itself from the inside. Sontag writes, "With the modern diseases (once TB, now cancer), the romantic idea that the disease expresses the character is invariably extended to assert that the character causes the disease—because it has not expressed itself. Passion moves inward, striking and blighting the deepest cellular recesses."[27]

When discussing AIDS, Sontag inverts this arrangement, noting the many military terms used to describe the syndrome: it's an invasion from the outside, an insurgency—as distinct from the internal mutations of cancer. Rather, AIDS took the place of cancer as the most stigmatized disease of the twentieth century, owing to

the dominant narrative that it is a disease of the "under-world" of gay men and intravenous drug users. Morally relegating gay men and drug users to a different class away from society allowed well-to-do, straight America to cordon off this population, and to feel distinct from and impervious to the threat of AIDS. It is through this stigmatization that individuals living with HIV and AIDS, which of course included many who didn't fit into the gay-male and drug-user stereotype, had to fight for the development of antiretroviral drugs and access to healthcare.

In dealing with the AIDS epidemic, the work of British artist Derek Jarman (1942–1994), a polymath who was among the first high-profile Britons to come out as HIV-positive, is both expressive and activist in nature. Jarman's work, which included painting, collage, writing, film, performance, gardening, and costume and set design, is very much a part of the tradition of expanding the scope of Institutional Critique beyond the museum and thinking of state government itself as an institution. It reflected his persistent public critiques of the Thatcher government and its antigay legislation. Amid his illness and slow death from AIDS, he lived in Prospect Cottage, his cabin on the coast of Dungeness, England, where he made a series of radically transparent collages about his illness. These collages are almost entirely black, made of tar and flotsam and jetsam found on the

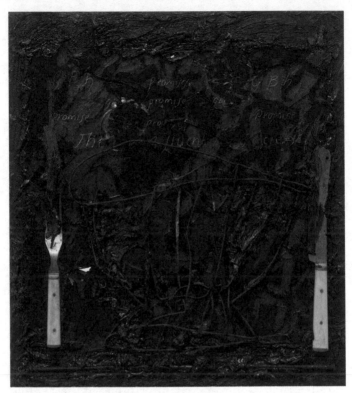

Derek Jarman, *Margaret Thatcher's Lunch*, 1987

coast, and symbolize the anguish he felt in dying. Some of them touch directly on political themes, such as *Margaret Thatcher's Lunch* (1987), in which a fork and knife, bloodied with red paint, rest atop a canvas topped with broken glass, metal, and barbed wire. Scratched on it are the phrases "GBH" (grievous bodily harm), "promises," and "the affluent society." The assemblage *One Day's Medication* (1993), completed a year before his death, attaches medication bottles and syringes to the canvas. One can see the traces of a life slowly fading: prescriptions for antifungal medications and antibiotics sit alongside antiviral medicines and a medication for toxoplasmosis infection. The works' sardonic anger reflects Jarman's own activities as an activist in the media: through his ventures in pop culture, making music videos for bands such as The Smiths and the Pet Shop Boys, and film collaborations with celebrities such as Sean Bean and Tilda Swinton,[28] Jarman thrust himself into the limelight. As a frequent subject of news media interviews, Jarman often made headlines for his amusingly coltish progay, anti-Thatcher statements. "Being gay is a blessing," he said in an interview shown at his 2019 retrospective *Protest!* at IMMA, Dublin, adding coyishly, "but because of society it can be a real problem."[29]

Perhaps Jarman's best-known work is the piece *Blue* (1993), a feature-length film with one static frame of the color blue as its only visual material. Against a musical

soundtrack, the piece brings together different story-lines that vary in verisimilitude. *Blue* is the last feature film Jarman made before his death from AIDS-related illnesses in February 1994 and poetically documents his life as a gay man living in London and dying of AIDS in the 1990s. The specific shade of blue in the film is International Klein Blue (IKB), which Jarman saw in painting form (*IKB 79*, 1959) at the Tate in 1974.[30] Jarman was influenced by Klein's mono-chromes, his associations of blue with the void, spirituality, and the sky. The color blue also took on a personal meaning for Jarman: due to his decline from AIDS, the artist was becoming blind and only able to see in shades of blue.

Blue exemplifies that, unlike some other practitioners of Institutional Critique, Jarman's work does not bear a skeptical approach to the commodity status of the art object: if anything, his works celebrate color, objecthood, and adornment. Yet, at the same time, he is extremely conscious of how his work functions within a capitalist system and, particularly in terms of the media, takes advantage of it to the extent that it can be taken advantage of. Moreover, Jarman makes an implicit critique of the universality of phenomenology associated with the primary apparatus of viewing art—the act of seeing—which is reflected back into its medium within the color blue. This medium-consciousness, and the treatment of governments and medical systems as a site, to me fulfills Fraser's criteria of critically reflexive site-specificity.

Third-Wave Institutional Critique

The third wave of Institutional Critique stands in distinction to the previous two in that it hasn't been canonized as a historical category. Yet the increased scrutiny of institutions, their staffs, and governance structures, complicated by economic instability and the COVID-19 pandemic, posits the urgency to further critically reflect on the field of art as a site of engagement. These artists and art workers seek to both improve representation in institutions, their programming and workforces, and to create material change. The artists of this wave work in conditions impacted by the social and economic changes brought by the Great Recession and subsequent economic recovery. In addition to introducing the framework I pose for the third wave, I will also outline in more detail the practices of several associated artists in order to trace the contours of this movement.

The economic effects of the 2008 financial crisis continue to be felt: despite experiencing economic recovery after the Great Recession, the US simultaneously experienced a decline in life expectancy, which fell from 78.9 years to 78.7 between 2014 and 2018.[31] While this might seem like a small or incidental change, longevity generally increases in tandem with a country's gross domestic product; the historical moments in which longevity

stagnates or declines indicate serious societal issues.[32] Increasing income disparity, the continuing privatization of public services, and the aftermath of the populism-affirming 2016 elections (both in the United States and abroad, as seen in countries such as Germany as well as the UK) have brought to a head the longstanding need for social movements such as Occupy Wall Street, #MeToo, and Black Lives Matter.

Taking these developments into consideration, the third wave posits the artist foremost as a person in relation to their surrounding material reality, which makes it possible, or not, to create artwork, be productive, and live a fulfilling life. The sphere that earlier iterations of Institutional Critique considered is thus broadened to include the very conditions of life, while still examining systems and structures as objects of critique. The artists that I associate with this wave vary in age and location. Nan Goldin (*1953), for example, is both a visual artist and activist leading the protest organization P.A.I.N. (Prescription Addiction Intervention Now). Goldin has noted how P.A.I.N. has drawn inspiration and adopted strategies from ACT UP, of which Zoe Leonard and Gregg Bordowitz were members. Other artists I connect with this wave include A. K. Burns (*1975), Hito Steyerl (*1966), Christine Sun Kim (*1980), and Cameron Rowland (*1988), who were all slated to exhibit work in *After Institutions*.

Furthermore, I would emphasize that the artists I have discussed thus far are primarily living and working in the United States and Europe. This is because the second and third waves are socially connected and defined, and, looking further back, the very foundation of the institution originated in Western Enlightenment. "The conceptual and actual history of the museum as we know it is fascinating and clear," writes former museum director and curator Steven Miller. "They are Western inventions that grew out of the Enlightenment and the age of exploration. Scholars, explorers, politicians, and cultural entrepreneurs found objects to be of immense personal and didactic value."[33] The institution as we know it thus has a specifically Western origin and history, and the institutions outside of the West have their own, oftentimes nation-specific lineages that correspond to the unique economic model and political circumstances of that nation. For example, in countries in which there is little or no public infrastructure for the arts, museums have arisen in the private sphere. Outside of the West, artists such as Liu Ding (*1976), working in Beijing, Park Chan Kyong (*1965), working in Seoul, and Gulf Labor (since 2011), working globally but focusing on the Emirates, have created bodies of work that reflect on museums in their respective countries, the expansion of these institutions, the relationship between this expansion and political and economic shifts, and, in the case of Park

Liu Ding, *The Orchid Room*, 2018

Chan Kyong and Gulf Labor, the ways in which this expansion can come at the expense of human rights.

Focusing particularly on China, artist and curator Liu Ding examines the ways in which museums are implicated in the production of national culture and historical narratives. His practice ranges from installations and exhibitions to painting and sculpture, and he authors his own theoretical and art-historical texts. Liu and I were long in conversation about presenting his 2018 project *The Orchid Room*, which references the Orchid Room in Beijing's Zhongshan Park. This Ming

Dynasty imperial garden abuts Tiananmen Square, which acts as an outer gate to the Forbidden City. The Orchid Room exhibits objects for connoisseurship of the Chinese literati, including orchids, Chinese paintings, and calligraphy. During his move north from Shanghai to Beijing in 1959, Chinese Communist Party General Zhu De (1886–1976) brought orchids to be exhibited in the park despite the capital city's colder climate. This move coincided with the launch of Mao Zedong's Anti-Rightist Campaign (1957–59), which politically persecuted hundreds of thousands of purported counterrevolutionaries, most of them intellectuals, for supposedly favoring capitalism over communism. This initiative transformed the People's Republic of China into a *de facto* one-party state. That the Orchid Room in Zhongshan Park materialized at the end of a campaign persecuting intellectual pursuits and was available to senior Communist Party members laid bare the contradictions defining the People's Republic of China on the brink of the Great Leap Forward and the Cultural Revolution.

With this in mind, Liu planned to recreate an Orchid Room and intersperse amid the flowers works from his *Conversations* series, which examines the possibilities of artistic production in China after a period of institutional and infrastructural expansion in the country in the 2000s, and a subsequent period of stagnation after the Great Recession. These private conversations

touch upon all aspects of artistic production in China and are represented in exhibitions by a simple rubric of still photographs, the time and date of the conversation, the participant list, and an outline of the topics discussed. Liu intended to complement this installation with watercolor paintings of a cruise ship struck by a COVID-19 outbreak in February 2020, trapping thousands of people on board—a popular news image, the tranquility of which is at odds with the reality of the tumult within.

My own conversations with Liu and his partner and frequent collaborator, the curator and art critic Carol Yinghua Lu, have been incredibly instructional. I spent an entire research trip to China in March 2019 researching how Institutional Critique could be defined there. What could such a movement *be* in a country that bears such a radically different history of modernism in comparison to the Western framework that birthed Institutional Critique? I posed this question to many people during that trip—some threw their hands up, and others just muttered "Ai Wei Wei." Yet it felt like there was something more at stake, something less flashy than Ai's surveillance cameras made out of marble. Liu answered my question: "Institutional Critique is simply addressing the omnipresent lack of opportunities afforded to artists in China—whether through language skills, the ability to travel and network to participate in exhibitions, or the

conceptual education of young artists." Liu's definition is thus an action—an address of systemic failures—which echoes Fraser's appeal to define Institutional Critique as a methodology rather than simply as work addressing institutions.

I took a research trip to Seoul, South Korea, in November 2019, and around that time the city's mayor had undertaken a cultural campaign that opened many public museums. Having become inured to constant institutional budget cuts in the United States and the Netherlands, this was a revelation. The work of South Korean artist Park Chan-Kyong further illustrates how the infrastructure of museums outside of the West has evolved in fits and starts. Similar to Liu Ding, Park is a polymath, working as an artist, art critic, and filmmaker. He also was a founding member of the influential project space Art Space Pool. His work has frequently reflected on Korean national identity, the division of the country, and modernity in relationship to Korean folk religion and shamanism. His 2019 exhibition *Gathering* at MMCA (National Museum of Modern and Contemporary Art, Korea) featured a sprawling maze of white walls, upon which hung his own works interspersed with ancient Korean art and artifacts. Handwritten notes dotted the walls, which were periodically pierced through with square-shaped holes, lending the appearance of windows to the maze of gallery walls.

The exhibition responded to well-known manmade disasters, such as the 2011 Fukushima nuclear accident and the sinking of the Korean Sewol Ferry in 2014, which killed 304 people. In light of the devastation of these disasters, Park suggests the museum aid in a system-wide reflection on modernity. In conversation with the *Korea Herald*, Park states, "I wanted to propose that museums are one of the few places left in the contemporary world where individuals can gather together, away from political, social, and economic interests."[34] In one of the window-like holes in the exhibition's walls, a monitor was placed, showing the sixteen-minute video *Small Museum of Art* (2019). The video tells the story of the four workers who died in a fire during the construction of MMCA Seoul—the very museum in which this show took place—and the *gut* ritual, or Korean traditional funerary rites, performed by shaman Kim Geumhwa to console the deceased. *Small Museum of Art* uses the site of its exhibition as a lens to reflect on broader societal failures. As a documentary video made within the context of contemporary art, it resonates with the activist strategies of the second generation, including the so-called coalition-building videos of Gregg Bordowitz.

Along with this continued penchant for activist methodologies, one of the most perceptible connections between the artists associated with this third wave is their interest in bodily and mental well-being. While

Park Chan-Kyong, *Small Museum of Art*, 2019

the connection between the AIDS crisis of the late 1980s and that of the COVID-19 pandemic is obvious, in 2021, many countries throughout the West had long been experiencing a systemic health crisis of a different character: the privatization of the healthcare system. Under a privatized and financialized healthcare system, for-profit companies take control of once-public services and, in turn, prioritize profit above quality of care. In this profit-driven context, healthcare becomes a privilege reserved for those who can afford it. Oftentimes the responsibility for care is placed on the individual. And if

ability is a privilege intersecting with race, class, gender, and sexuality, one notices an overlapping of race, class, gender identification, and ability: the most marginalized communities are disproportionately affected by disability and illness precisely because they have less access to sufficient healthcare, particularly in the United States.

However, illness and disability need not be seen as a burden but rather a fact of life, foreseeable and possibly manageable with proper resources. In this vein, care shouldn't be understood as a debt that must be repaid or reciprocated. Touching on these points, the artist and writer Carolyn Lazard (*1987) has written about the paradoxical imperative placed on productivity in creative sectors, which all but puts chronically ill artists in the position of being asked to "produce" at an untenable rate, thus excluding them from a system that would ostensibly like to welcome them.[35] This, writes Lazard, is a hallmark of capitalist thinking—one that is so internalized that even the most well-intentioned doctors, colleagues, family members, and friends may have a difficult time identifying this demand on productivity as part of a damaging ideology.

Working through these themes, Lazard participated in the landmark exhibition *Trigger: Gender as a Tool and Weapon* (2017), curated by Johanna Burton at the New Museum of Art in New York. For the work *A Conspiracy* (2017), Lazard installed in the museum's oversize

Carolyn Lazard, *A Conspiracy*, 2017

elevator a grid of twelve Dohm white noise generators, a relatively unevolved analog electronic technology frequently found in therapists' offices to ensure privacy or in bedrooms to facilitate sleep. Intentionally misusing these machines by locating them in the high-traffic museum context populated by public-facing workers, Lazard sought to queer their use and use value. In this way, *A Conspiracy* ventured to stimulate private, potentially conspiratorial conversations in the midst of the repressive visible and representational politics of art

institutions. Coming from a lineage of Institutional Critique that includes Fraser and Wilson, *A Conspiracy* was intended to serve the community of art workers and visitors, disabled and nondisabled, who are frequently erased as active participants in the art world, specifically museum guards.

Much of Lazard's work deals with slowing down, or waiting, in "crip time." In addition to their solo artistic practice, they also belong to the Canaries, a group of artists who are living with autoimmune conditions and other chronic diseases. Taraneh Fazeli, one of the core members, curated an exhibition at the Elizabeth Foundation of Art Project Space in New York titled *Sick Time, Sleepy Time, Crip Time: Against Capitalism's Temporal Bullying* (2017), to which Lazard and their frequent collaborator Jesse Cohen contributed an installation replicating a medical waiting room and a publication that includes contributions by Canaries members focused on the concept of waiting, in both practical and metaphorical terms. Lazard's durational performance work, *Support System (for Tina, Park, and Bob)* (2016), took place at an apartment residency in Brooklyn, and finds Lazard in bed, receiving individual viewers in thirty-minute increments over the course of an entire day, throughout twenty-four sessions in total. These works posit rest as an act of resistance rather than weakness, as it is sometimes understood, and assert that the necessity of care is the rule, rather than the exception.[36]

Lazard's works reference *Visiting Hours*, a performative installation by Bob Flanagan (1952–1996) and Sheree Rose (*1941), whose work I had selected for *After Institutions*. *Visiting Hours* was shown within popular exhibitions at the Santa Monica Museum in 1992 and the New Museum in 1994. Bob Flanagan—in his last years before succumbing to cystic fibrosis—stationed himself in the museum in a replica hospital room, acting as the exhibition's command post and information center, interacting with visitors. The installation extended throughout the New Museum's gallery space, featuring wallpaper, sculptures, and a replica waiting room. The exhibition also highlighted Flanagan and Rose's involvement in the BDSM subculture in Los Angeles—drastically invigorating the popular vision of the disabled body as lifeless and sexless. While Flanagan and Rose were working in the same period as many of the artists in the second wave, they were not strongly socially connected. In conversation with Mark Dion in January 2020, he told me that Flanagan and Rose's New Museum exhibition was something of a revelation to him and his New York–based community.[37] With Flanagan's illness due to cystic fibrosis, their work considered finding (sexual) agency amid certain death, which found meaningful overlaps with the works by artists living with HIV and AIDS.

The legacy of the second wave Institutional Critique artists is reflected in younger generations due to the

formers' continued work as art school professors and mentors. Andrea Fraser is both a professor and Chair of the Department of Art at UCLA; Gregg Bordowitz is a professor in the School of the Art Institute of Chicago's Department of Film, Video, New Media, and Animation and the director of SAIC's Low-Residency Master of Fine Arts program; Mark Dion is a Visual Arts Mentor at Columbia University, and they all remain involved with the Whitney Independent Study Program.[38] A graduate of the Whitney ISP, Park McArthur (*1984) reflects on institutional conventions across a range of spheres, from real estate and architecture to caregiving. Her work *Welcome to PS1* (2015) makes a slight intervention in a series of promotional framed photos in MoMA PS1's lobby vestibule. The photos outline key moments in the institution's history and the formation of its identity, characterizing itself as magnanimous and forward-thinking: the foundation of the school building that went on to house PS1, the opening of it as an art center in 1978, the hanging of a David Hammons flag outside, the beginning of its popular "Warm Up" concert program. To this series she adds another photo, framed identically to the others, of a pole banner hanging on the street outside PS1 that states "MAKE IT HERE LONG ISLAND CITY MAKE IT YOURS." This image refers to a promotional collaboration between the Long Island City Partnership—an organization with the dubious mission to "advocate for

Park McArthur, *Welcome to PS1*, 2015

[A daytime image of a banner attached to a street lamp. The streetlamp is turned off. The banner reads "MAKE IT HERE LONG ISLAND CITY MAKE IT YOURS" and is positioned between a glass skyscraper on the left and a luxury apartment building under construction on the right. Below the image black text repeating the Long Island City phrase is followed by the year 2015.]

Hito Steyerl, *Guards*, 2012

economic development that benefits the area's industrial, commercial, tech, cultural, tourism, and residential sectors"—and the Suffolk County National Bank. McArthur thus draws attention to the entanglement of art institutions in a complex web of economic and social interests, including those of real-estate developers and banks. In another work, *Ramps* (2014), McArthur arranged wheelchair ramps that were previously made for her in order to access various otherwise nonaccessible institutions where she was either in an exhibition or on residency. This work highlights how institutions themselves are sites of either exclusion or support, and the paradox of a museum mounting a well-intentioned exhibition on access while not being accessible itself.

Though Hito Steyerl's work is popularly understood as examining advanced technology through immersive video installations, so too has it considered for decades the art institution, the democracy behind its access, as well as the nexus between its architecture, real estate, the economy, and proximity to the state. Born in Munich in 1966, Steyerl lived in Munich and Berlin throughout the 1990s, studying and working within the German documentary film industry, and as such had no proximity to artists associated with Pat Hearn Gallery and American Fine Arts, Co. I had also invited Steyerl to participate in *After Institutions* with her work *Guards* (2012). This modestly sized work follows two Black American security

guards throughout the museums in which they work, unveiling portraits of them and their pasts, which were both marked by military service, trauma, and loss.

Having personally known Steyerl as a friend and collaborator for over a decade, working on an exhibition with her was a soft place to land after the canceling of the *After Institutions* exhibition. Steyerl's practice ventures to make sense of our lived experience, and to do so she examines the amalgamation of many different facets of society—this is what gives her work its acuity, but also may cause some people to lose the thread. One of my goals as curator of her solo exhibition was to deepen the professional audience's understanding of her work while introducing her practice to the amateur audience.[39] This desire prompted me to look at the very beginnings of her career, when she was studying documentary filmmaking at Hochschule für Fernsehen und Film München (University of Television and Film Munich) from 1992–98. The works from this period largely examine the reunification of Germany and the societal upheaval that it caused. The following surge of nationalism—long seen as taboo because of the genocide begot by the nationalist Nazis (literally the Nationalsozialistische Deutsche Arbeiterpartei or National Socialist German Workers' Party)—complemented increased acts of antisemitism and xenophobia, often perpetrated on the street. Within the Stedelijk exhibition, Steyerl's video installations and

environments filled an entire wing of the ground floor, while a thematic exhibition comprising her older works, as well as some more recent pieces, filled the museum's first-floor "Hall of Honor." This exhibition comprised many of the themes we had discussed in preparation for *After Institutions*, and placed *Guards* in the middle of the Hall of Honor, viewable at the top of the Stedelijk's grand staircase. Several of her older works, such as *Deutschland und das Ich* (1994) and *Babenhausen* (1997), are installed on a steel pipe structure holding standard-definition flat screens. Other works in the gallery include the architectural installation *Der Bau* (2009), and *Die Leere Mitte* (1998), the feature-length film documenting the development of Berlin's Mitte district after the fall of the Berlin Wall, specifically the speculation surrounding Potsdamer Platz. Lastly, there's *Drill* (2019), a work commissioned by and touring the building of the Park Avenue Armory, which historically acted as the birthplace of the National Rifle Association.

Although the framework of waves is helpful for understanding how social conditions have impacted artistic production of a given moment, many artists work throughout multiple waves, or are (reductively) thought to embody only certain historical moments. Steyerl, for instance, given her birth year, could easily be the contemporary of second-wave Institutional Critique. Similarly, artist Joseph Grigely (*1956) is a generation older

than McArthur and Lazard, and thus by age could be considered part of second wave Institutional Critique—yet Grigely's continuing work with disability activism places him in orbit with the third wave. Grigely's work takes the form of installations, and the artist is particularly interested in art and law because, as he once wrote to me, "in both you are trying to get people to let go of their preconceptions of the world, and accept it from a different perspective."[40] Grigely considers his lawsuit against the Gramercy Park Hotel for multiple flagrant violations of the Americans with Disability Act a work of art. Titled *United States of America, Plaintiff, vs. GPH Management, LLC, as owner of the Gramercy Park Hotel and RFR Hotel Group, LLC, as Operator of the Gramercy Park Hotel, Defendants* (2011), the lawsuit recounts Grigely's 1996 visit to the Gramercy Park Hotel as an artist participating in the Gramercy International Art Fair. While there, he tried to make a telephone call with a tele-device-for-the-deaf, or TDD. Though it was over five years since the passage of Americans with Disabilities Act in 1990, which stipulates that hotels must have a TDD on the premises, the hotel didn't have this essential equipment. Almost ten years later, in 2004, Grigely came back to stay at the Gramercy Park Hotel, and it still didn't have the device. Through a complaint, Grigely compelled the Department of Justice, New York Attorney General, and New York City Human Rights Commission to bring

charges against the hotel. The whole case lasted fifteen years and was settled in 2011 by consent decree, an agreement or settlement that resolves a dispute between two parties without admission of guilt or liability. For *After Institutions*, Grigely and I were in conversation about what form this project could take within the exhibition—whether as a video, display of documents from his archive, or another form of installation. So, too, were we in conversation about the exhibition of a project he had discussed presenting with Pat Hearn in 1992: a disability resource room created to educate others about the ADA, passed two years earlier.

By homing in on institutional failures, Grigely's work lays bare the emotional labor required of people living with disabilities in order to navigate society. His lawsuit and work on emotional labor bring to mind the work of feminist scholar Sara Ahmed, who has been researching the subject of complaint at institutions and educational organizations. While complaint is an act that holds abuses of power accountable and is vital to the health of an organization, the emotional toll it takes to complain is enormous. In point of fact, those who aim to lodge complaints are oftentimes discouraged from doing so. A year into the pandemic, Grigely published "Inventory of Apologies," which literally brings together apologies he has received from institutions that had organized online talks made inaccessible without captions—a glaring

issue for the deaf, hard of hearing, and neurodivergent made particularly acute amid the pandemic.[41] The apologies range from flippant, to overly formal and removed, to complete recognition of the inherent ableism in forgetting to provide captions. Some of the apologies may even come across as relatable. Taken together, however, these excuses—over forty in total—echo each other with such maddening monotony that their totality becomes abundantly clear: able-bodied people are not socialized to think beyond their own conception of "normal" needs, and, because of this, people living with disabilities must continually request the simplest forms of accommodation. It doesn't have to be this way.

Thus Grigely, alongside other artists using legal and judicial frameworks, such as Cameron Rowland and Maria Eichhorn (*1962), defends access to institutions and their services, as well as other human rights, via legal actions presented as artworks. In turn, this administrative aesthetic harkens back to the self-reflexive modernist element of very early Institutional Critique outlined in Buchloh's text. Through the display of found objects, historical documents, and artifacts, Rowland's work attests to how the effects of slavery and colonialism still define and stratify society today, and bears witness to centuries of racial capitalism: the process of extracting value from people of a different racial identity, structured by antiblackness and slavery. For *3 & 4 Will. IV c. 73*,

their 2020 exhibition at Institute of Contemporary Arts, London, Rowland looked toward the institution's building to consider the infrastructure of property ownership. The mahogany features that make up 12 Carlton House Terrace, which houses the ICA, was originally sourced with slave labor from the former British colonies of Jamaica, Barbados, and Honduras. The ICA's tenancy there continues to be a source of rental income for the Crown. Rowland's works titled *Encumbrence* impose limits on this continued accumulation. They arrange the mortgage of the ICA's mahogany architectural features, including its doors and staircase handrails, to Encumbrance Inc., a legal entity set up by Rowland with the purpose of defaulting on payment and depriving the Crown of revenue.[42] This construction appropriates the eighteenth-century practice of extending predatory loans to colonial subjects, who would default and put up their land as collateral in the form of a mortgage.

If one were to consider that Broodthaers's *Décor* exhibition happened at the same institution nearly a half-century earlier, it's interesting to consider the reverberations and dissonance between the two artists' works. Broodthaers thought of the institution as the logical meeting place between state ideology and art and often refers to the production of the national identity of his home country, Belgium, in his work. As such, the potted palms in the *Décor* exhibition critically refer to Belgium's

colonial exploitation of Africa in modern-day Democratic Republic of the Congo, Rwanda, and Burundi. Forty-five years after Broodthaers's exhibition, and 187 years after the United Kingdom's 1833 Abolition of Slavery Act, Rowland's work attests to the continuation of the financial transgressions originating in slavery. "Abolition," Rowland writes, "preserved the property established by slavery."[43]

Further, thinking back to the anti-aesthetic strategy, the works of Rowland and Grigely fit seamlessly into this rubric. Their conceptual apparatus exists in the forceful arrangement of material change outside of the gallery, with its aesthetic representation inside the gallery as textual documents. Similarly, the other artists in this section—Lazard, McArthur, and Steyerl—all create works that make sense of lived experience with testaments to which their audiences may not otherwise be exposed.

1 This text was published in the catalog for the 1989 exhibition *L'art conceptuel: Une perspective*, curated by Claude Gintz at the Musée d'art modern de la Ville de Paris, and later published in the Winter 1990 edition of *October* journal.

2 Benjamin H. D. Buchloh, "Conceptual Art 1962–1969: From the Aesthetic of Administration to the Critique of Institutions," *October* 55 (Winter 1990): 136.

3 Andrea Fraser, "From the Critique of Institutions to an Institution of Critique," in *Institutional Critique and After*, ed. John C. Welchman (Zurich: JRP Ringier, 2006), 130.

4 Ibid., 305–06.

5 Christina Chan, "'Hans Haacke: All Connected': Gallery-Goers' Birthplace and Residence Profiles (1969–71)," audio guide, 2:35 min., uploaded by New Museum, https://archive.newmuseum.org/sounds/15857.

6 Fraser 2006 (see note 30), 129.

7 Ibid., 132.

8 Daniel Buren, "The Function of the Studio," trans. Thomas Repensek, *October* 10 (Autumn 1979).

9 Hans Haacke, "All the Art That's Fit to Show," in *Museums by Artists*, ed. A.A. Bronson and Peggy Gale (Toronto: Art Metropole, 1983), quoted in Fraser 2006 (see note 30), 128.

10 Bühler 2022 (see note 2).

11 "Identity politics" is a loaded term that is often used to pejoratively describe the purportedly dogmatic thinking around race and gender in the artwork of the early 1990s. While it's most often used as a nuanced slight by people threatened by the increased attention toward work reflecting on race and gender, I believe Meyer simply finds this political framework insufficient and calls for a more holistic consideration of politics in the contemporary art of that moment.

12 Gregg Bordowitz and Douglas Crimp, "A Conversation Between Douglas Crimp and Gregg Bordowitz, January 9, 1989," in Jan Zita Grover, *AIDS: The Artists' Response*, exh. cat. Hoyt L. Sherman Gallery (Columbus, 1989), 8.

13 Christina Kreps, "Changing the Rules of the Road: Postcolonialism and the New Ethics of Museum Anthropology," in *The Routledge Companion to Museum Ethics: Redefining Ethics for the Twenty-First-Century Museum*, ed. Janet Marstine (New York: Routledge, 2011), 70–84.

14 Karen Zraick et al., "Police ID Suspect in Stabbing of MoMA Employees," *The New York Times*, March 14, 2022, section A, 11.

15 Buren 1979 (see note 35).

16 This quote is popularized by Mark Fisher and, according to him, is attributed to both Fredric Jameson and Slavoj Žižek. See Mark Fisher, *Capitalist Realism: Is There No Alternative?* (Winchester, UK: Zero Books, 2009).

17 Nina Quabeck, "Intent in the Making: The Life of Zoe Leonard's 'Strange Fruit,'" *Burlington Contemporary* (May 2019), https://contemporary.burlington.org.uk/journal/journal/intent-in-the-making-the-life-of-zoe-leonards-strange-fruit.

18 Miwon Kwon, *One Place After Another: Site Specific Art and Locational Identity* (Cambridge, MA: MIT Press, 2002), 30.

19 *Contemporary Critical Practice: Reinventing Institutional Critique*, ed. Gerald Raunig and Gene Ray (London: Mayfly Press, 2009).

20 Gerald Raunig, "Instituent Practices: Fleeing, Instituting, Transforming," in ibid., 4.

21 Vincenzo De Bellis and Caroline Dumalin, eds., *Mario García Torres: Illusion Brought Me Here*, exh. cat. Walker Art Center and WIELS Contemporary Art Center (Minneapolis and Brussels, 2019), 90.

22 Cahier Journal, "A Discussion between Ann Goldstein (Stedelijk Museum, Amsterdam and Philipp Kaiser (Museum Ludwig, Cologne)," *Cahier* 19 (March 1, 2013), https://web.archive.org/web/20140602200344/http://www.stijl.de/cahier/news/cahier19-news.html.

23 While this sounds eerily similar to Fraser's definition of Institutional Critique, I would not consider myself as enacting Institutional Critique as a curator on this project. Perhaps a lower designation of "institutional analysis" would fit.

24 United States Department of Labor, "Tips," https://www.dol.gov/general/topic/wages/wagestips#:~:text=A%20tipped%20employee%20engages%20in,equals%20the%20federal%20minimum%20wage.

25 See Lisa Lee, *Isa Genzken: Sculpture as World Receiver* (Chicago: University of Chicago Press, 2017), 1–5.

26 Susan Sontag, *Illness as Metaphor and Aids and Its Metaphors* (New York: Penguin Random House, 1991), 91.

27 Ibid., 47.

28 See Jarman's numerous films featuring Swinton: *Caravaggio* (1986), *Aria* (1987), *The Last of England* (1987), *L'Ispirazione* (1988), *War Requiem* (1989), *The Garden* (1990), *Edward II* (1991), *Blue* (1993), *Wittgenstein* (1993).

29 Jane Ure-Smith, "Derek Jarman: A Major Meeting of Art and Activism," *Financial Times*, November 22, 2019, https://www.ft.com/content/3c5abbdc-09fe-11ea-8fb7-8fcec0c3b0f9.

30 Jennelyn Tumalad, "Stepping into Blue," blogs.getty.edu (blog), November 1, 2016, https://blogs.getty.edu/iris/stepping-into-blue/.

31 Woolhandler et al. (see note 4), 3.

32 Ibid.

33 Steven Miller, *Museum Collection Ethics: Acquisition, Stewardship, and Interpretation* (London: Rowman & Littlefield, 2020), 2.

34 Shim Woo-hyun, "Park Chan-kyong's 'Gathering' Explores What Museum Can Become," *The Korea Herald*, October 30, 2019, http://www.koreaherald.com/view.php?ud=20191030000675.

35 Carolyn Lazard, "How to Be a Person in the Age of Autoimmunity," *Cluster Mag* (2013); see also https://static1.squarespace.com /static/55c40d69e4b0a45eb985d566/t/58cebc9dc534a59fbdbf98c2 /1489943709737/HowtobeaPersonintheAgeofAutoimmunity +%281%29.pdf.

36 Julia Pelta Feldman, "Carolyn Lazard: Support System," *www.roomandboard.nyc*, n.d., https://roomandboard.nyc/salons/carolyn -lazard-support-system/.

37 Private conversation with Mark Dion in Chelsea, New York City, January 10, 2020.

38 Mark Dion was a professor and mentor of mine via my studies at the School of the Art Institute of Chicago (2003–08), where his Mildred's Lane residency program with J. Morgan Puett was offered as an elective. Through Dion I met Moyra Davey, Jason Simon, Jeff Preiss, and, later, Andrea Fraser. Though I never had Gregg Bordowitz as a professor at SAIC, I worked with him on various initiatives within the school's Visual and Critical Studies Department.

39 Hito Steyerl, *I Will Survive*, Stedelijk Museum Amsterdam, January 29 – June 12, 2022.

40 Quote from email exchange with the artist February 2, 2021.

41 Joseph Grigely, "Inventory of Apologies," *VoCA Journal* (December 7, 2020), https://journal.voca.network/inventory-of-apologies/.

42 Cameron Rowland, *3 & 4 Will. IV c. 73*, Institute of Contemporary Arts, London, January 28 – December 13, 2020.

43 Ibid.

III
Conclusion

The question of audience is central to conversations surrounding Institutional Critique and, more broadly, the paradoxes surrounding the field of contemporary art today. Who, exactly, makes up this field—who is *inside* of it, and whom does it let in? How is the museum visitor, who may not be as knowledgeable within our professional sphere, included? I think about how, in institutional exhibitions, museum curators are meant to fantasize about what a general audience's knowledge base might be and what they might want to see. These exhibitions concoct the specter of a person who is seen but not heard within the museum's walls, with marketeers longingly grasping at the foot of their heels. The field has educated itself into a corner, producing a mutually exclusive disconnect between those who run the museum and the public it serves.

In turn, this question of position is further crucial to understanding the past and potential futures of Institutional Critique: Where, exactly, does critique come from

today? As I've outlined in this text, pressure upon institutions comes from *everywhere*, from every political leaning, from inside and outside of the field. From within the field, we're dealing with a reckoning with the conditions produced by the institution. As outlined in this book, the museum's representational issues abound in their collections and staff makeup; their progressive programming belies a lack of progress on a material front, compounded by a lack of care in creating humane labor conditions.

Yet is this pressure upon institutions tantamount to Institutional Critique? Yes and no. Fraser's own definition is simultaneously inclusive, cast as a methodology that can be attributed to various fields and roles, yet also quite narrow, positioning the act of critique as only internal. For me, the most urgent remaining question surrounding the contemporary definition of Institutional Critique is: How can we reconcile this internal position with the historical exclusion of certain groups from the canon? And, relatedly, what of the people who have come up through the field who, regardless, feel genuinely excluded by it? What of all the recent "discoveries" of septuagenarian and octogenarian female artists who had been toiling away in their studios for decades without any significant notice from those working in museums, galleries, and universities? What of the people who cannot work in institutions because the ableist workforce will not accommodate their basic needs, or whose expertise

isn't recognized because of their subject position—for those who anonymity is but regulation wear? Do they not exist, to some extent, outside of the field? Perhaps this is a matter of terminology: Fraser believes that all critique is internal critique—to be able to identify how a field must change necessitates a deep familiarity with it. One must have profound enough stakes in the field to want to tear it down and know how to build it back up. While Institutional Critique is generally only considered as the product of an artistic practice, so too can one be working in the vein of Institutional Critique when enacting resistance within or around institutions.

But what, then, would critique coming from an external position look like? I would argue that there is a neo-avant-garde impulse to tear down institutions as we know them from a hybrid internal-external position, and thus the contemporary position of Institutional Critique is defined by this insider-outsider relationship. Scores of artists and art workers are choosing to walk away from institutions and *not* participate in the conditions they produce. Exhibition boycotts are but one example: in 2014, nine artists withdrew from the 19th Biennale of Sydney in protest of the biennale's connection with Transfield Holdings, a stakeholder in the operation of mandatory detention centers for those seeking asylum in Australia, located in Papua New Guinea.[1] There are also the eight artists who chose *not* to participate in the 2019 Whitney

Biennial, in protest of issues with the museum's governance outlined in this text.[2] Similarly, in the aftermath of George Floyd's death on May 25, 2020, in June 2020 in the Netherlands three open letters calling for change in the Dutch cultural sector were published, all suggesting that the current funding structures and overly white staff makeup of these institutions is insufficient as it currently stands. One even called for the literal destruction of current cultural infrastructure and its subsequent rebuilding.[3] This revolutionary impulse brings to mind that over the course of 2020, nearly 100 Confederate monuments were removed in the US.[4] Throughout the world, monuments have been forcibly toppled as if to suggest the history that begot them—and institutions that commissioned them—could also be upended.

Given that a variety of societal and economic factors have brought institutions to their current nadir, what can be expected of them at this juncture? Can museums act as temples when for decades they've been forced to operate like shopping malls? Can we do anything to help institutions, to challenge them at a structural level, or are we at a dead end? If the field were to consider the distribution of power in a more holistic manner and deem stakeholders to exist throughout the museum, and not just in the director's office and curatorial department, we would come to a more integrated sense of ethics within the institution. We're currently seeing plenty

of inspiring initiatives afoot: unionization drives are popping up throughout the US; there's increased scrutiny on boards and governance structures; there's more accountability for the contextualization of an artist's practice and biography; honoraria for artistic labor are becoming more standardized. Moving forward, if one is lucky enough to come into a position of power, we can ourselves ensure that the material labor conditions that we offer are humane. Care, in this instance, is the rejection of normalized exploitative working practices, the rejection of using others as shortcuts to protect budgets, saying no to bringing collaborators into a project that cannot foster hospitable relations and equitable standards, treating artists with a collaborative spirit. We can look to care as a popularly shared and expanded sense of ethics for reckoning with the enduring inequalities that have founded and continue to be produced by our field.

Since its inception, the institution has always mounted exhibitions, collected artworks and artifacts, and acted as a repository for ideas. This, itself, is rife with chance and opportunity. That these core operations remain intact centuries later is a testament to their strength in purpose within society. Just as institutions can generate inequality, so too can we find evolution within the institution, out of a self-directed desire to do better, to change. It can also be impelled from the outside, from those attentive to the missteps and problematics institutions have

instantiated from their founding. This insider-outsider dichotomy thus defines the contemporary position of critique. After all, critique is the act of holding accountable something that we love, that we want not just to survive, but to flourish.

1 See Sarah Cascone, "Artists Make Good on Threat to Boycott Biennale of Sydney," *Artnet News*, February 26, 2014, https ://news.artnet.com/art-world/artists-make-good-on-threat-to -boycott-biennale-of-sydney-2679#:~:text=This%20is%20a %20statement%20of,and%20relinquished%20our%20artists' %20fees; see also the #19BoS Working Group blog, http ://19boswg.blogspot.com/2014/03/four-more-artists-withdraw -from-19th.html.
2 Colin Moynihan, "Eight Artists Withdraw from Whitney Biennial over Board Member's Ties to Tear Gas," *The New York Times*, July 21, 2019, section A, 22.
3 See Domeniek Ruyters, "Open Brieven: De Nederlandse kunstwereld is te wit – doe er iets aan," *Metropolis M*, June 20, 2020, https ://www.metropolism.com/nl/features/41217_open_brieven_de _nederlandse_kunstwereld_is_te_wit_doe_er_iets_aan.
4 See Rachel Treisman, "Nearly 100 Confederate Monuments Removed In 2020, Report Says; More Than 700 Remain," *NPR*, February 23, 2021, https://www.npr.org/2021/02/23/970610428/nearly-100 -confederate-monuments-removed-in-2020-report-says-more-than -700-remai?t=1649004945064.

Acknowledgments

Enormous thanks to Nicholas C. Morgan, Danica Pinteric, and Lloyd Wise for their thoughtful and generous feedback on this text. Also, thank you to the artists initially slated for participation in *After Institutions*, as well as my conversation partners in this research: Melanie Bühler, Kate Cooper, Kristian Handberg, Margot Norton, Hito Steyerl, Judith Vrancken, and Vivian Ziherl. Thank you to the New Museum, Sculpture Center, and the University of Copenhagen for allowing the generous partial republishing of essays originally commissioned by them. I also greatly appreciate the support of Jort van der Laan of Studium Generale at Gerrit Rietveld Academie, Laura Herman of KASK-School of Arts Ghent, S.M.A.K. and Ghent University for their invitations to speak about *After Institutions* amid the pandemic. Thank you to the Stedelijk Museum Amsterdam for allowing this research to come to life in written form. Lastly, thank you to Aaron Bogart for this commission, for always lending an ear, and for fostering this book into what I'd envisioned it to be.

Biography

Karen Archey is Curator of Contemporary Art at the Stedelijk Museum Amsterdam. She is a 2015 Creative Capital | Warhol Foundation Arts Writers Grant recipient for short-form writing. Since joining the Stedelijk Museum in April 2017, Archey has organized solo exhibitions by artists Rineke Dijkstra, Catherine Christer Hennix, Steffani Jemison, Metahaven, Jeff Preiss, Charlotte Prodger, and Hito Steyerl. She has written numerous catalogue essays and is a contributor to several art publications, including *Artforum* and *Frieze*.

Image Credits

P. 40
Mel Bochner, *Working Drawings
and Other Visible Things on Paper
Not Necessarily Meant to Be Viewed
as Art*, 1966. Four identical
3-ring binders, each with 100
photocopies of studio notes,
working drawings, and diagrams
collected by the artist, each:
11 ¾ × 11 ½ × 3 ⅛ in. (29.8 × 29.2
× 7.9 cm); © Mel Bochner;
Courtesy of the artist

P. 43
Lawrence Weiner, *A SQUARE
REMOVAL FROM A RUG IN
USE*, 1969. Photograph, text sheet:
felt pen on paper, 8.27 × 6.3 in.
(21 × 16 cm); © VG Bild-Kunst,
Bonn 2022; Courtesy of Mumok,
Vienna

P. 49
Hans Haacke, *Toch denk ik, dat U
mij niet de juiste motieven toeschrift*
(But I Think You Question My
Motives), 1978–79; 3 light boxes:
black Formica, black-and-white
transparency, blue silkscreen
transparency, color transparency;
central panel: 79 ¾ × 54 × 11 ⅞
in. (202.5 × 137 × 30 cm); left and
right panels: 60 ⅞ × 41 × 10 in.
(154.5 × 104.4 × 25 cm); © Hans
Haacke/VG Bild-Kunst, Bonn
2022; Courtesy the artist and
Paula Cooper Gallery, New York

P. 61
Zoe Leonard, *Strange Fruit*,
1992–97. 295 bananas, oranges,
grapefruits, lemons, and avocado
peels, thread, zippers, buttons,
sinew, needles, plastic, wire,
stickers, fabric, trim, wax;
dimensions variable; Collection
Philadelphia Museum of Art:
Purchased with funds contrib-
uted by the Dietrich Foundation
and with the partial gift of
the artist and the Paula Cooper
Gallery, 1998, 1998-2-1.
© Zoe Leonard; Courtesy of the
artist, Galerie Capitain, Cologne,
and Hauser & Wirth, New York;
Photo: Graydon Wood

P. 62
Zoe Leonard, *Strange Fruit*, 1992–
97. Installation view, Philadelphia
Museum of Art, Philadelphia.
© Zoe Leonard; Courtesy of the
artist, Galerie Capitain, Cologne,
and Hauser & Wirth, New York;
Photo: Tom Powel

P. 67
Mario García Torres, *Preliminary
Sketches from the Past and for the
Future (Stedelijk Museum)*, 2007.
Video, 4 min.; © Mario García
Torres; Courtesy of the artist,
Stedelijk Museum, Amsterdam,
and neugerriemschneider,
Berlin

P. 68
Josh Kline, *15% Service (Applebee's Waitress' Head)*, 2018. 3-D-printed sculptures in plaster with inkjet ink and cyanoacrylate, custom tray, wooden stand, 38 ¼ × 28 ½ × 28 ½ in. (97.2 × 72.4 × 72.4 cm); © Josh Kline; Courtesy of the artist and 47 Canal, New York

P. 71
Isa Genzken, *Ohr (Ear)*, 1980. Series of six framed photographs, 69 × 46 in. (175 × 118 cm); © VG Bild-Kunst, Bonn 2022; Courtesy of Stedelijk Museum, Amsterdam; Photo: Gert Jan van Rooij

P. 74
Derek Jarman, *Margaret Thatcher's Lunch*, 1987. Oil and mixed media on canvas, 18 × 16 in. (45.7 × 41.2 cm); © Keith Collins Will Trust Collection IMMA, Dublin, Ireland; Courtesy of Amanda Wilkinson Gallery, London

P. 80
Liu Ding, *The Orchid Room*, 2018. Installation, dimensions variable; © Liu Ding; Courtesy of the artist

P. 85
Park Chan-Kyong, *Small Museum of Art*, 2019. Video, 15 min. 50 sec. Installation view at MMCA, Hyundai Motor Series 2019: *Park Chan-Kyong – Gathering*, MMCA, Seoul, Korea; © Park Chan-Kyong; Courtesy of the artist. Photo: Hong Cheolki

P. 87
Carolyn Lazard, *A Conspiracy*, 2017. Dohm white noise machines, dimensions variable. Installation view *Trigger: Gender as a Tool and a Weapon*, New Museum, New York, 2017; Courtesy the artist and New Museum, New York. Photo: Maris Hutchinson/EPW Studio

P. 91
Park McArthur, *Welcome to PS1*, 2015. Digital C-print: 8 ½ × 11 in. (21.59 × 27.94 cm), 9 ½ × 12 in. (24.13 × 30.48 cm) (framed). MoMA PS1, Long Island City, New York. Long-term installation; © Park McArthur; Courtesy of the artist and Maxwell Graham/Essex Street, New York

P. 92
Hito Steyerl, *Guards*, 2012. Ed. 5 + 2 AP, single-channel video, color video, stereo audio, 1080px × 1920px. Installation view, Hall of Honor; © Hito Steyerl; Courtesy of the artist and Stedelijk Museum, Amsterdam; Photo: Peter Tijhuis

Every effort has been made to trace the copyright holders and obtain permission to reproduce this material. The publisher apologizes for any errors or omissions in the above list and would be grateful if notified of any corrections that should be incorporated in future reprints or editions of this book.

Colophon

Series editor:
Aaron Bogart

Editor:
Nicholas C. Morgan

Copyediting:
Jude Macannuco

Reader:
Danica Pinteric

Proofreading:
Julie Astor

Graphic design:
Daniela Burger

Typesetting:
Lena Rossbach

Reproductions:
Falk Messerschmidt

Typeface:
Kelvin Avec Clair

Printing:
druckhaus köthen

Paper:
Fedrigoni Constellation Snow,
Munken Print White

© 2022 Floating Opera Press,
Berlin, and the author

Published by
Floating Opera Press
Hasenheide 9
10967 Berlin
www.floatingoperapress.com

ISBN 978-3-9819108-8-9

Printed in Germany